W9-CEI-462

animorphia

An Extreme Coloring and Search Challenge

KERBY ROSANES

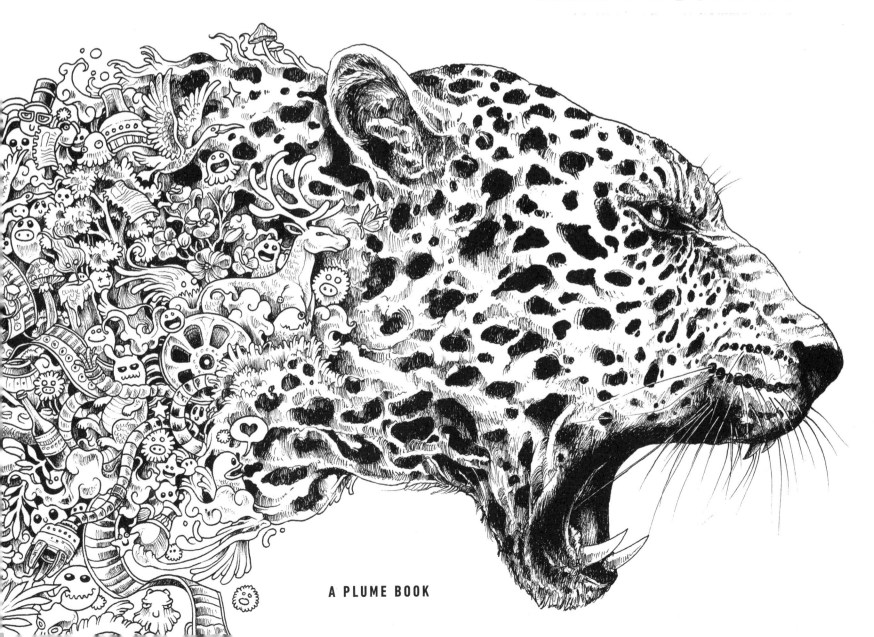

A PLUME BOOK

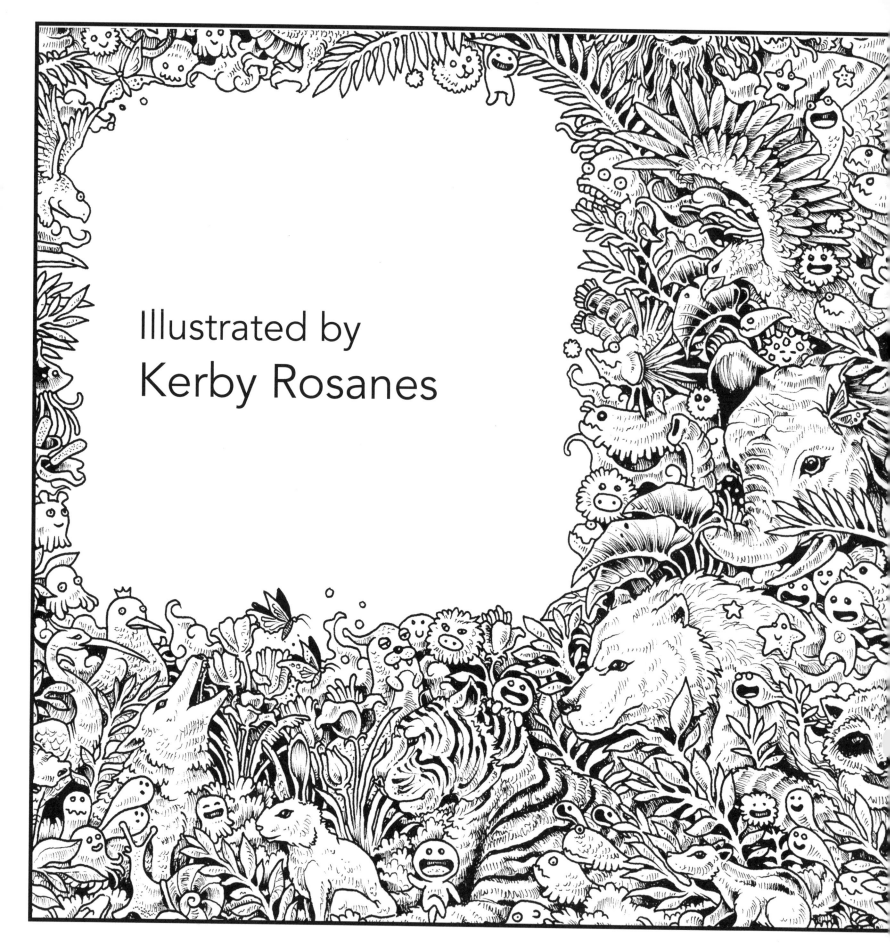

Illustrated by
Kerby Rosanes

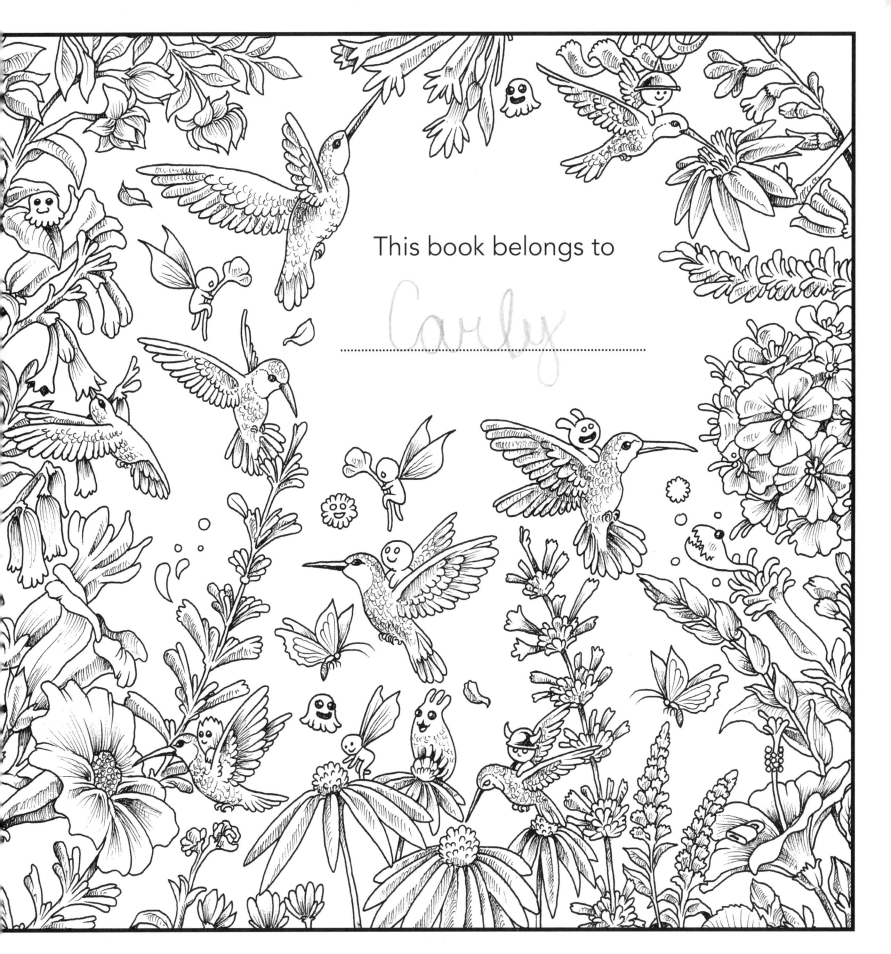

This book belongs to

Carly

Edited by Jonny Marx
Designed by Zoe Bradley

With thanks to Hannah Thornton
for being a great talent scout

PLUME
An imprint of Penguin Random House LLC
375 Hudson Street
New York, New York 10014

First published in Great Britain by LOM ART,
an imprint of Michael O'Mara Books Limited, 2015
First American edition by Plume 2015

Copyright © 2015 by Michael O'Mara Books Limited
Penguin supports copyright. Copyright fuels creativity, encourages diverse voices,
promotes free speech, and creates a vibrant culture. Thank you for buying an authorized
edition of this book and for complying with copyright laws by not reproducing, scanning,
or distributing any part of it in any form without permission. You are supporting
writers and allowing Penguin to continue to publish books for every reader.

℗ REGISTERED TRADEMARK—MARCA REGISTRADA

ISBN 978-0-14-751836-1

Printed in Canada
5 7 9 10 8 6

Welcome to this creative coloring adventure!

Delve into my high-definition, super-detailed doodle world, where strange creatures morph and meld into amazing animals and beguiling beasts.

Each detailed drawing has been crafted with fineliner pens and can be colored in any way you like. There are also doodle pages that you can complete, customize, and embellish in black line.

Keep your eyes peeled for unusual objects scattered throughout the pages. You'll find a list of hidden treasures that you need to search for at the back of the book (along with all the answers).

Kerby Rosanes

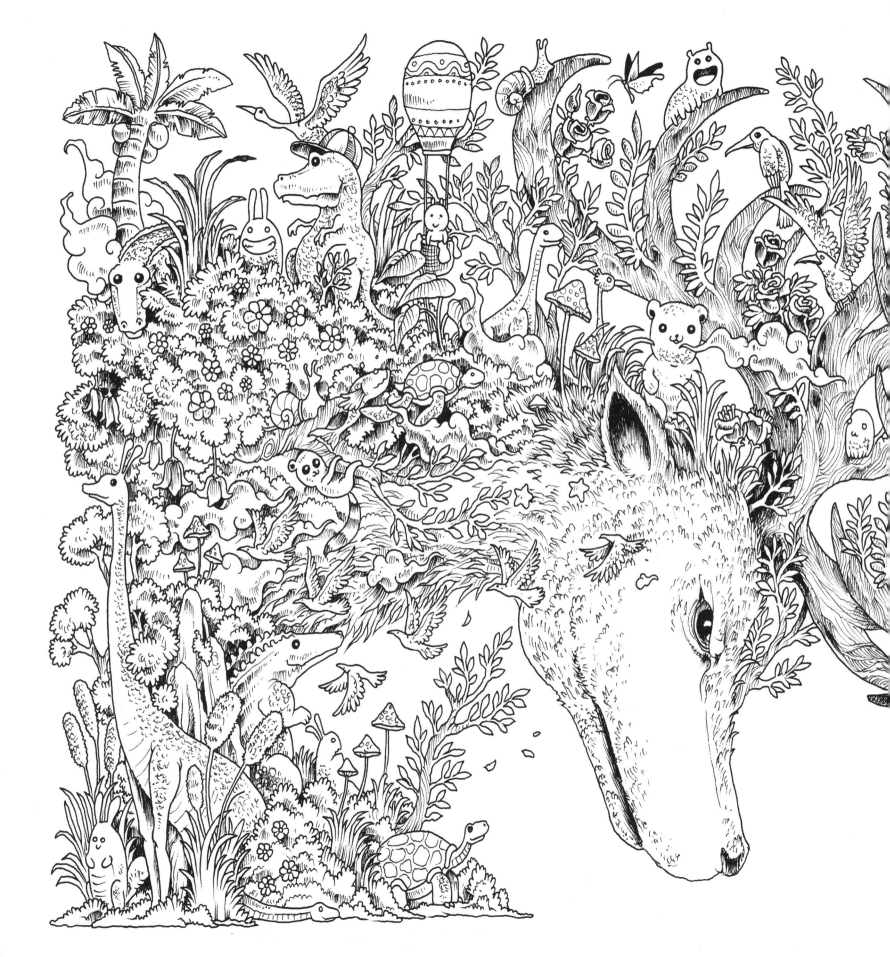

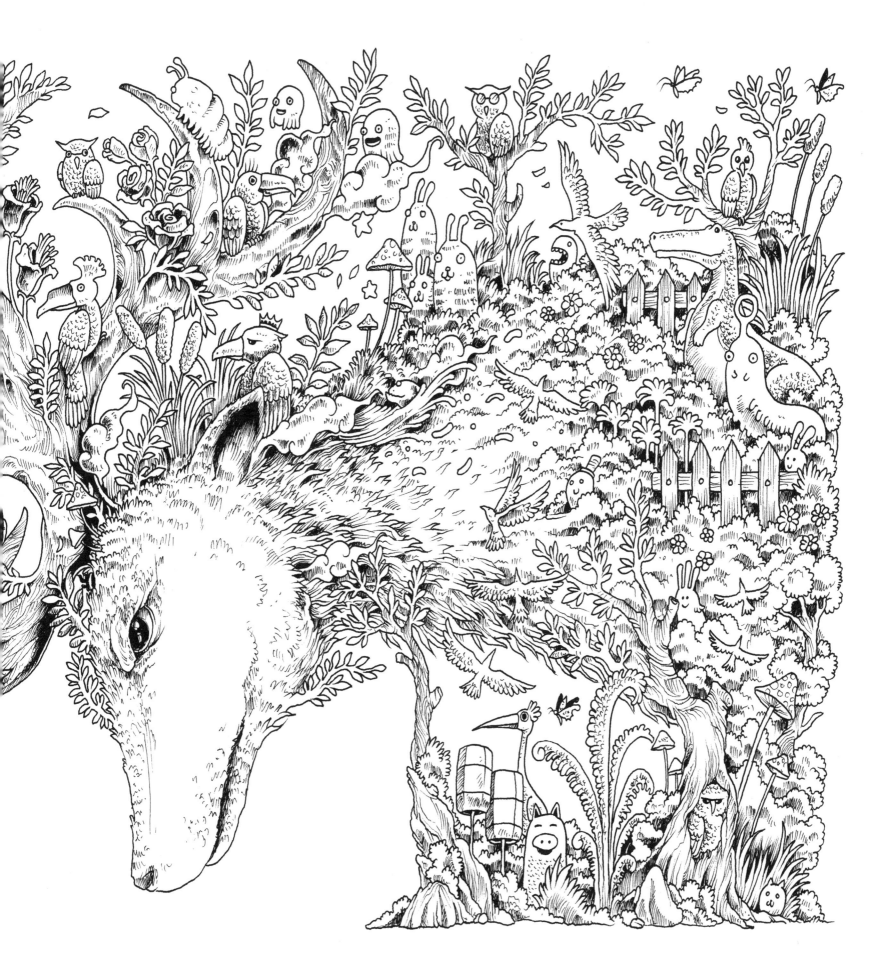

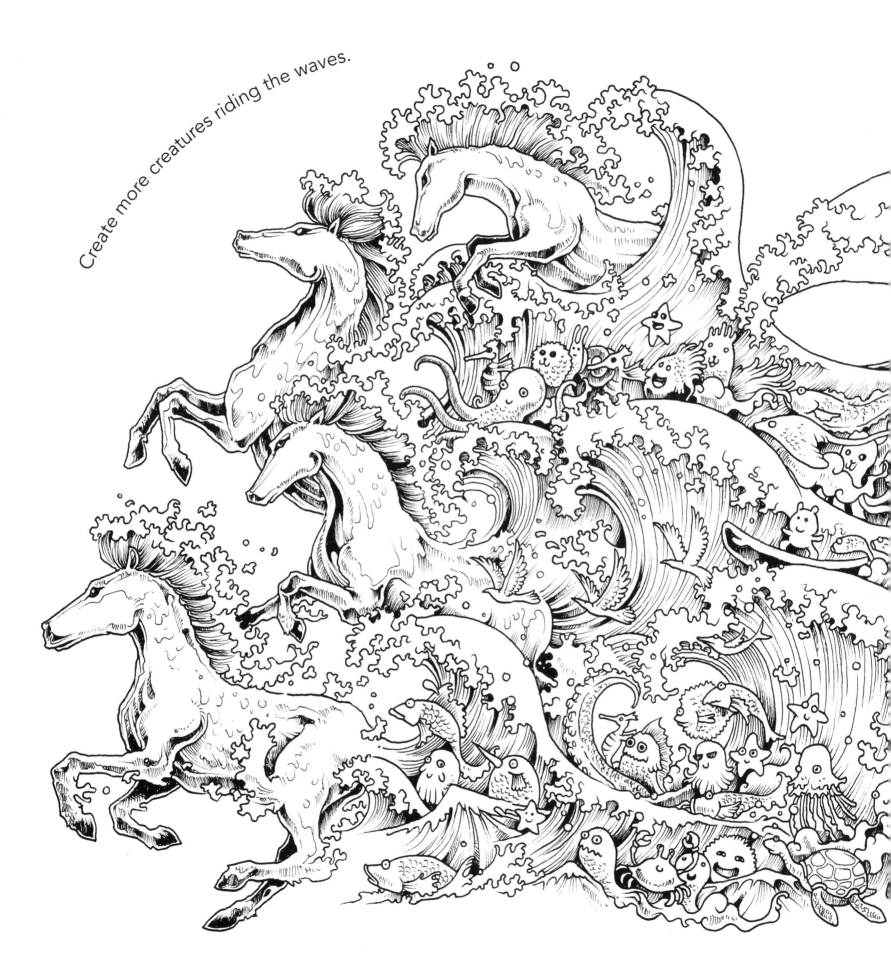

Create more creatures riding the waves.

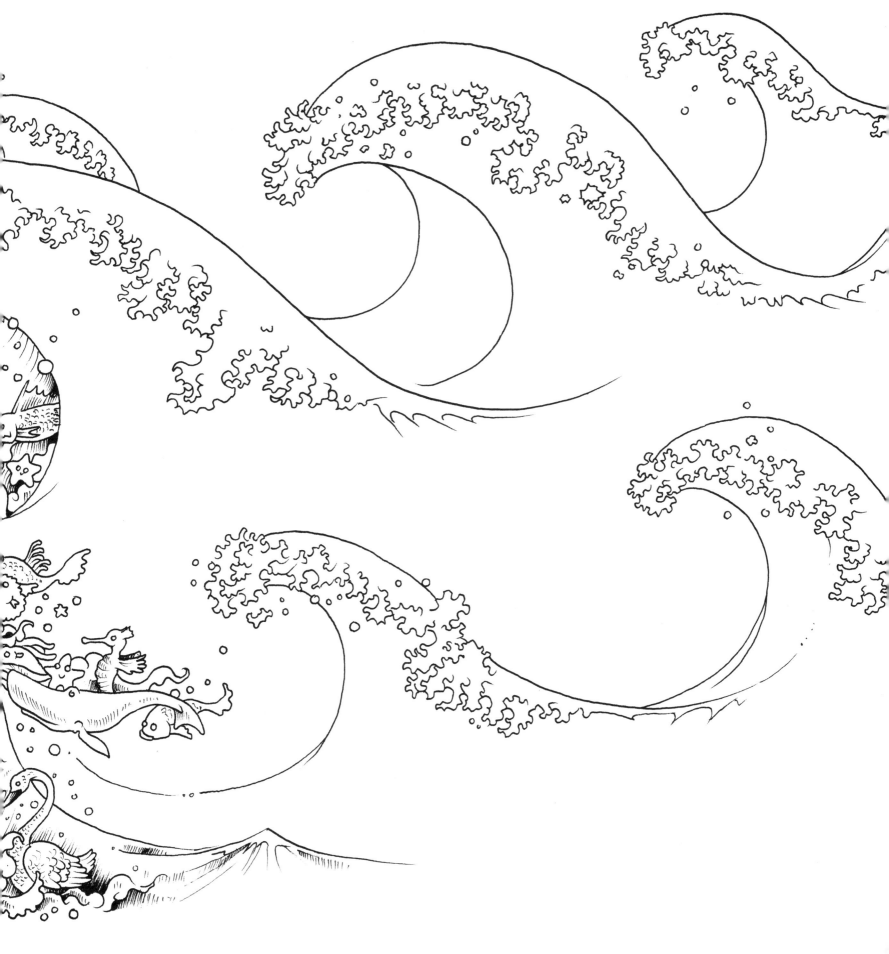

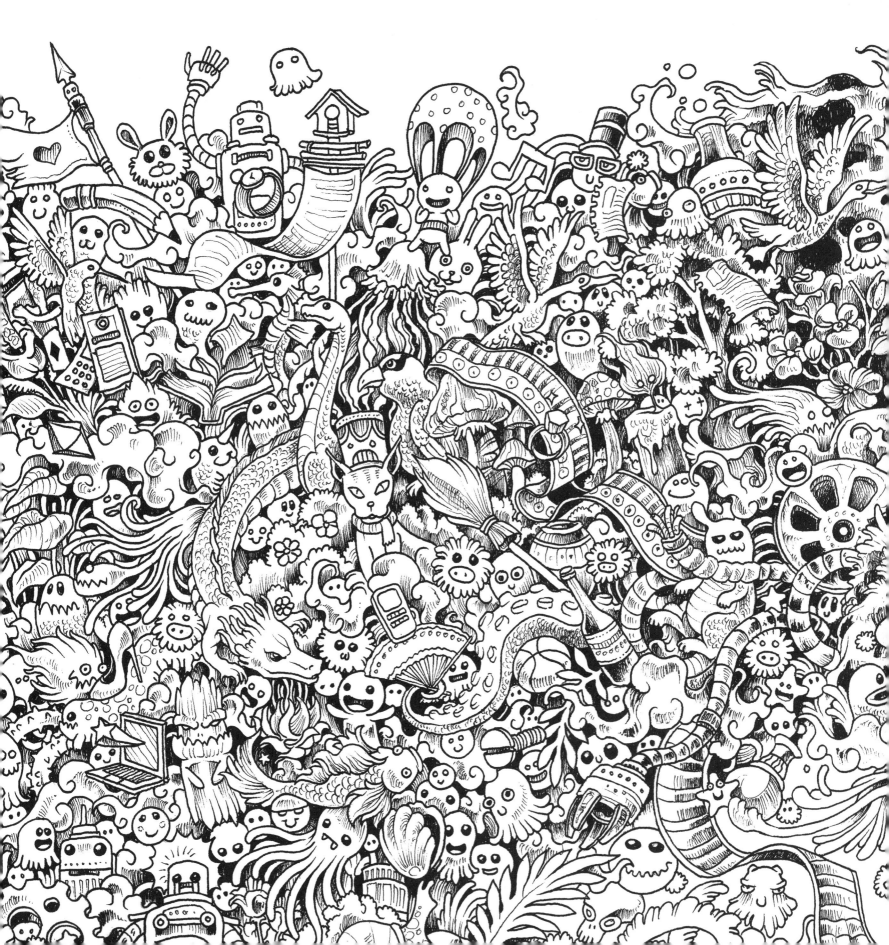

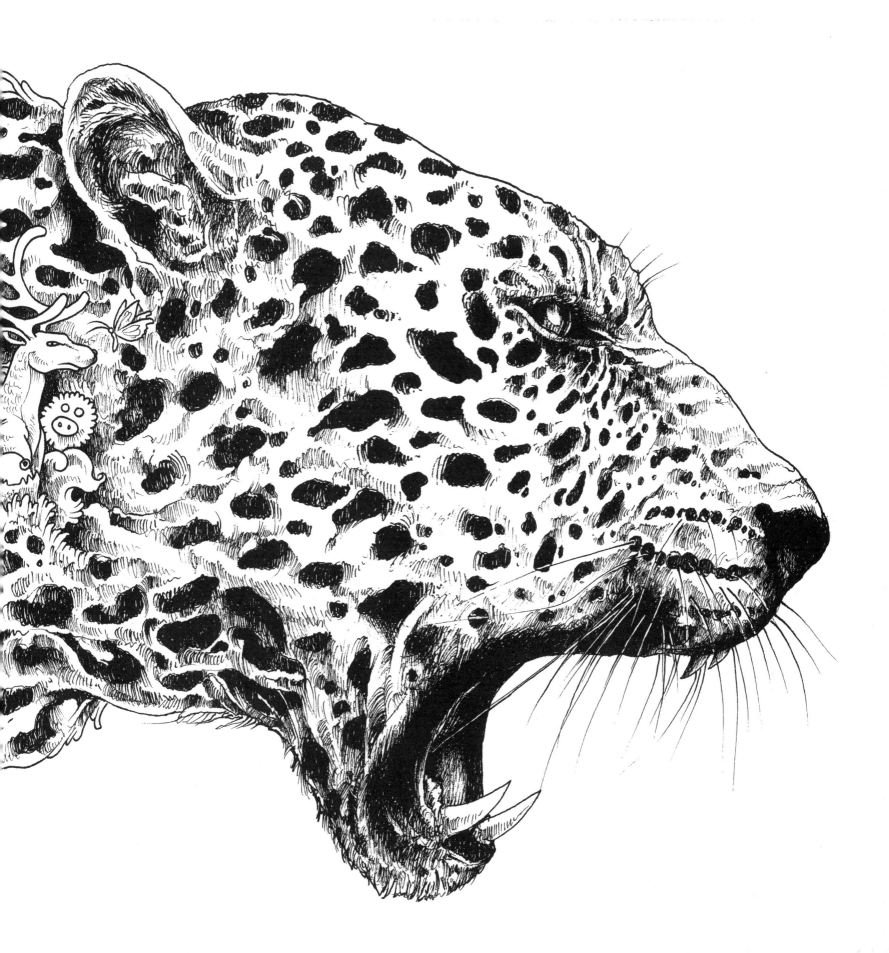

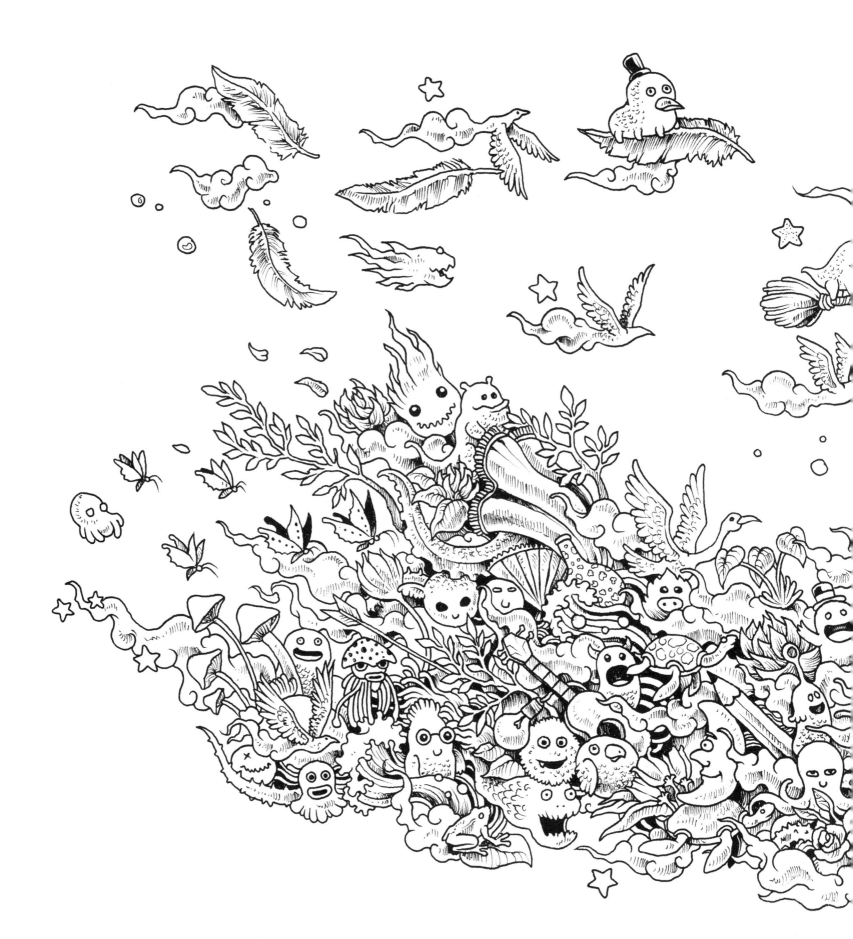

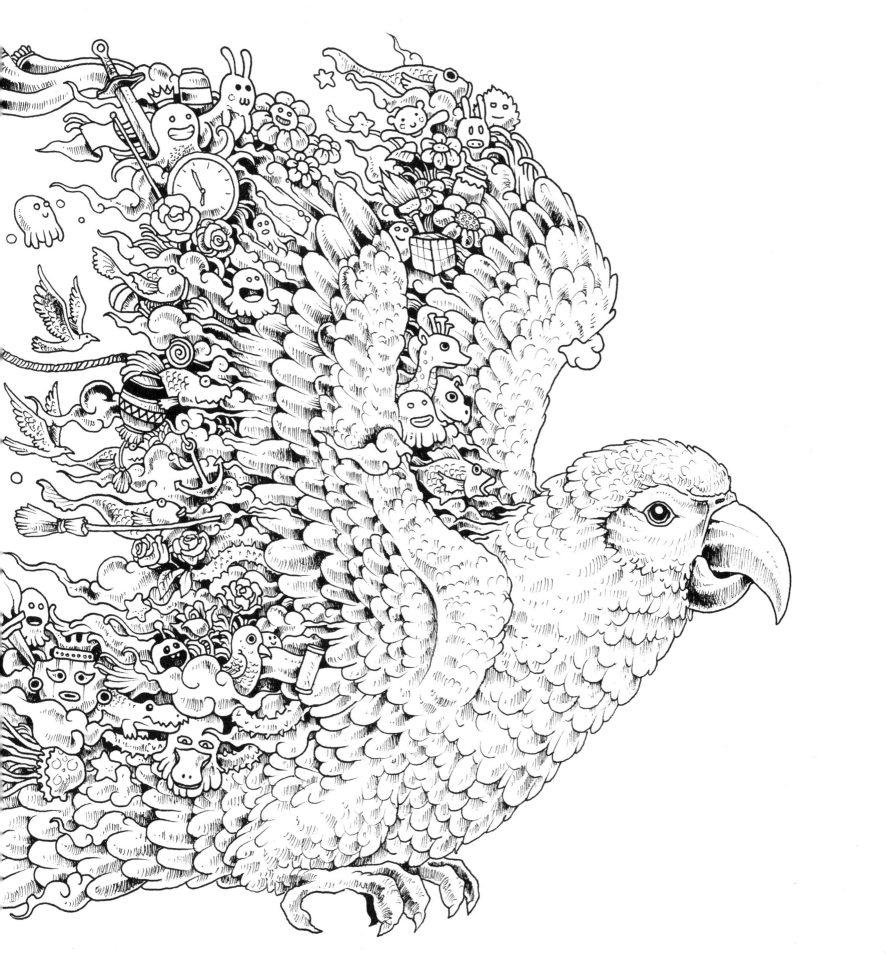

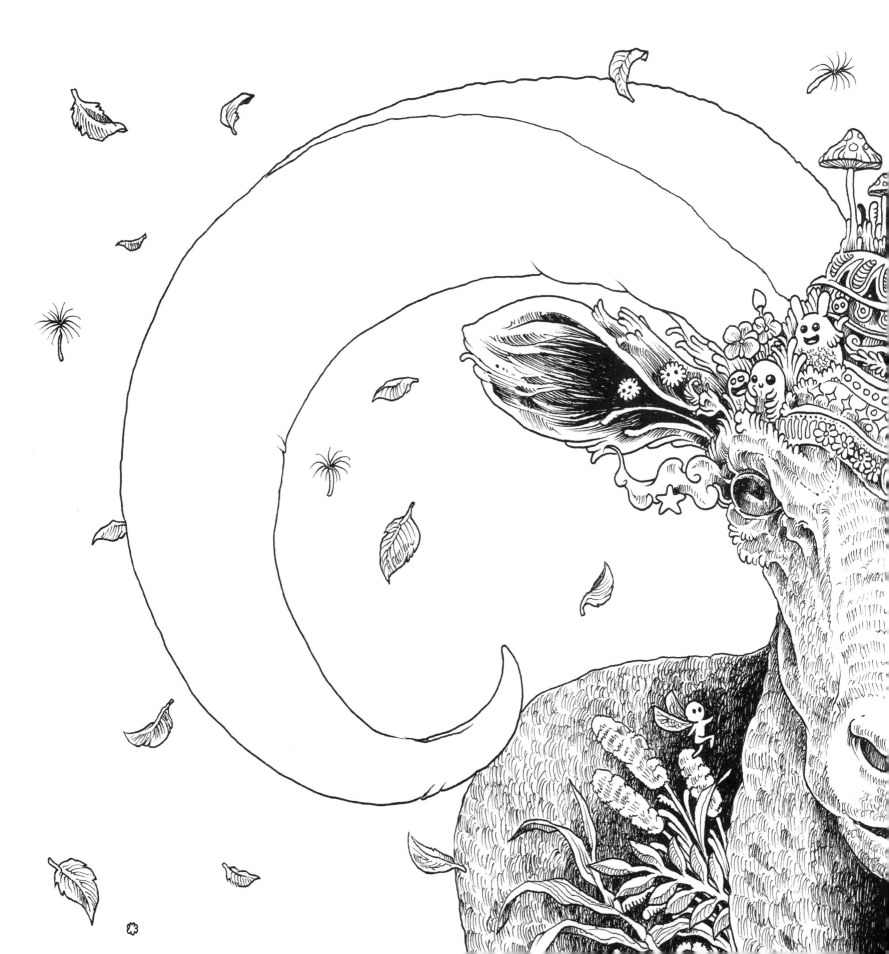

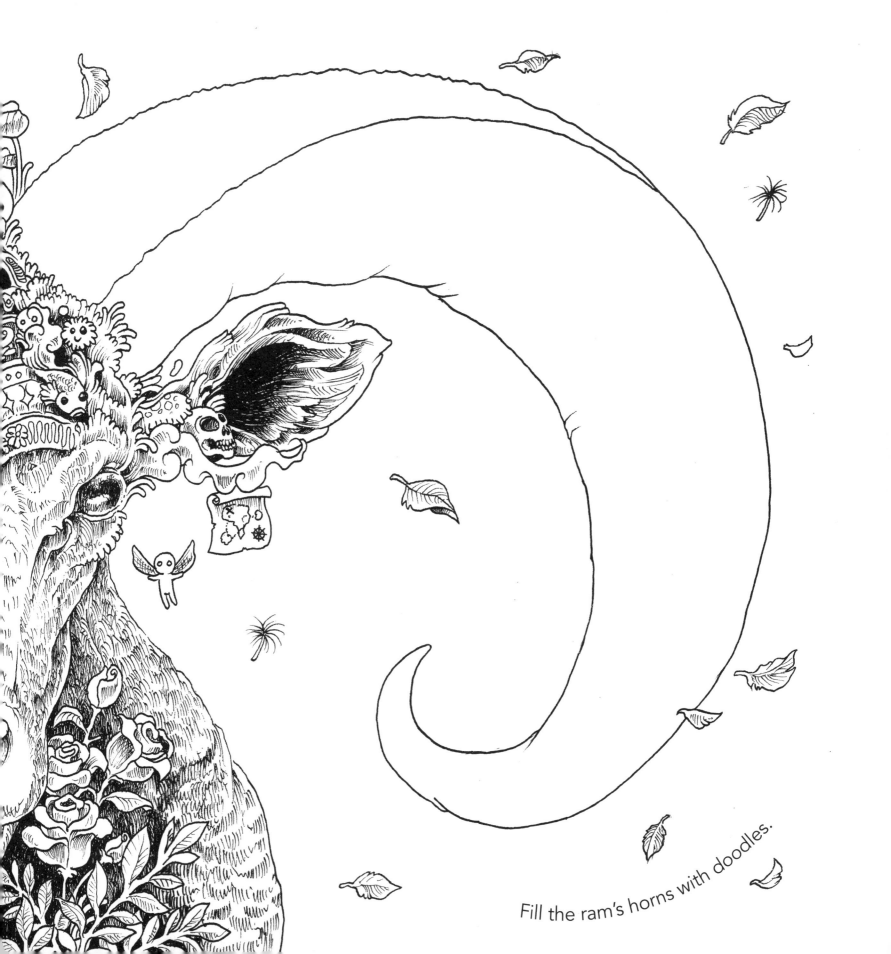

Fill the ram's horns with doodles.

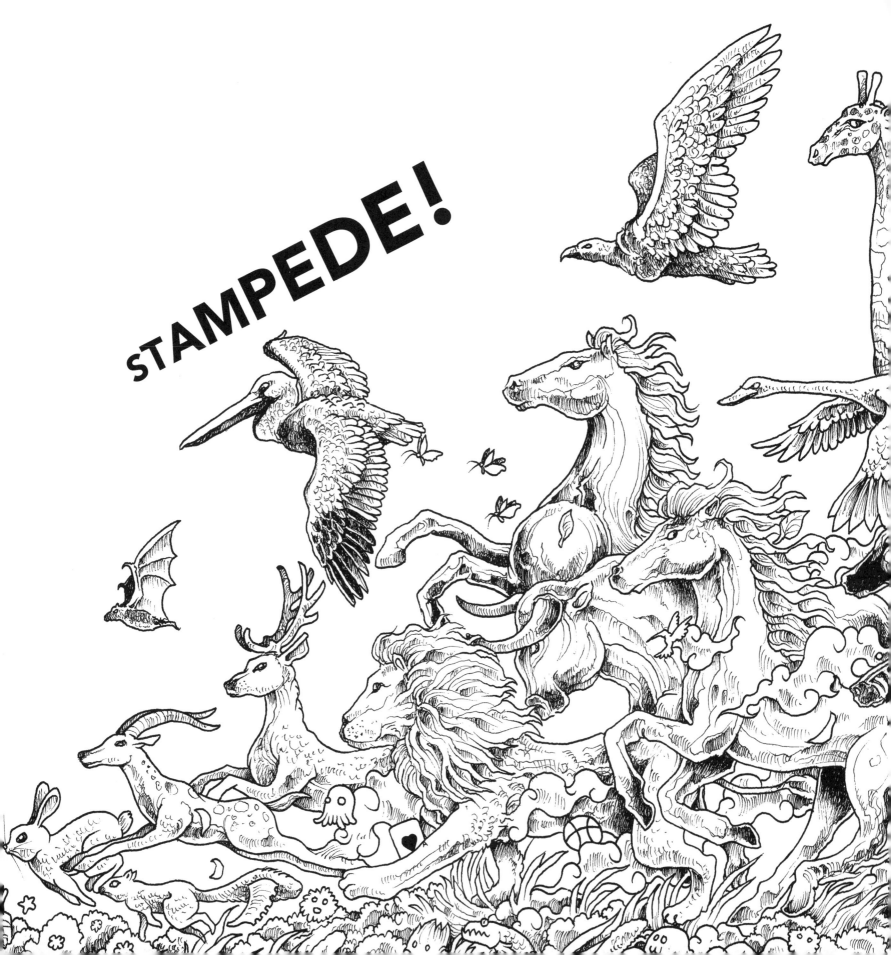

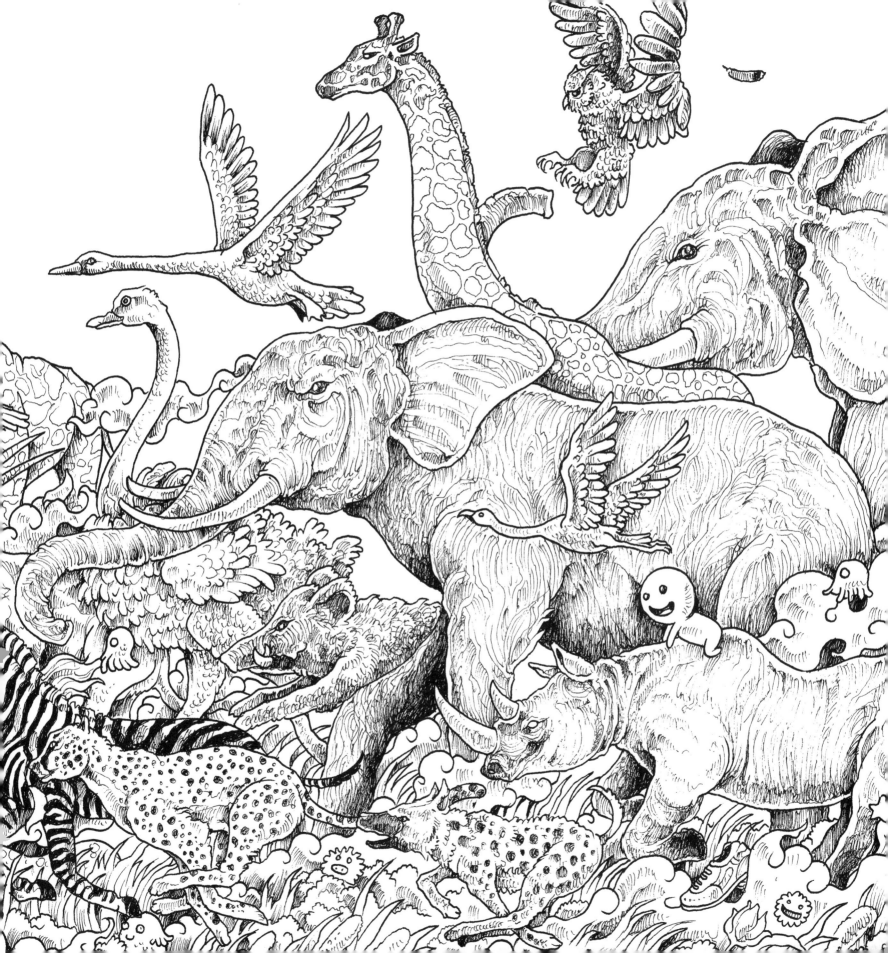

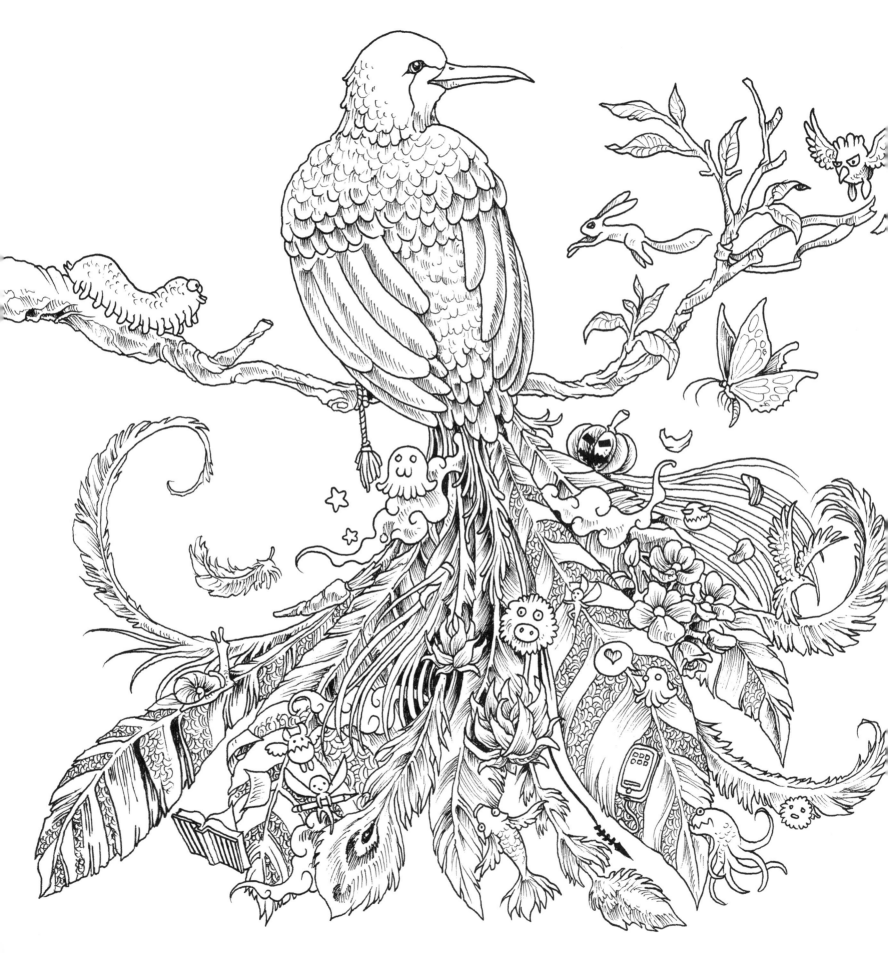

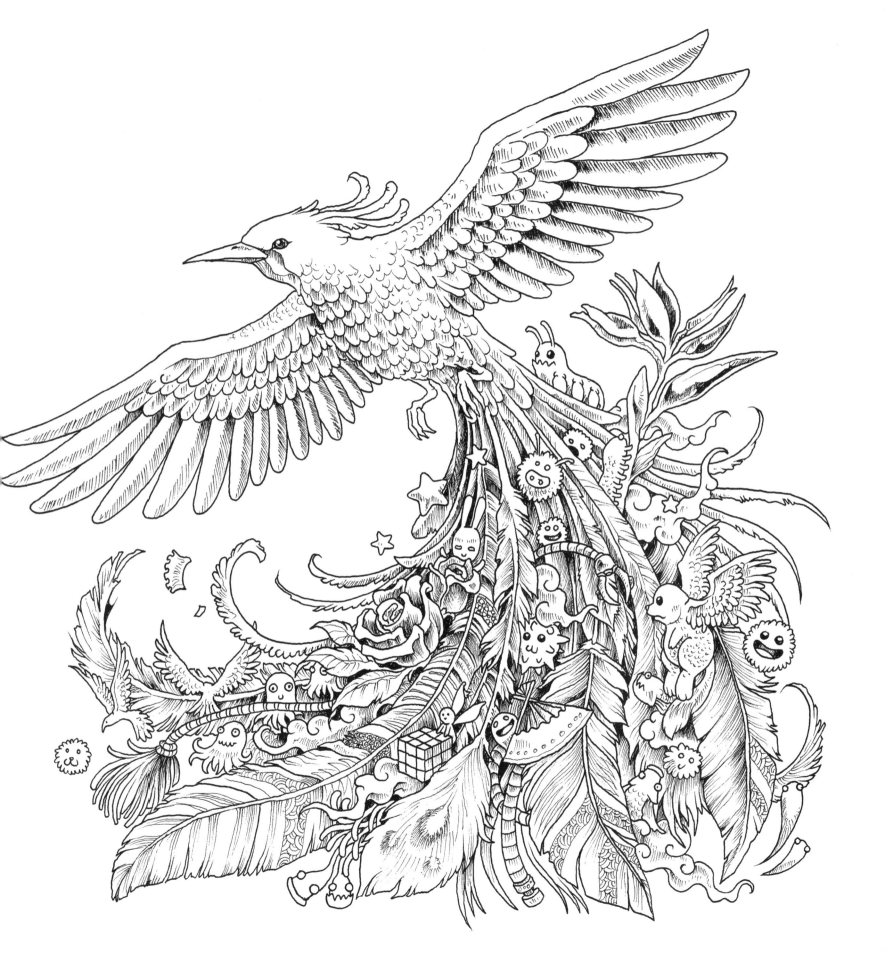

Fill the butterflies
with detail.

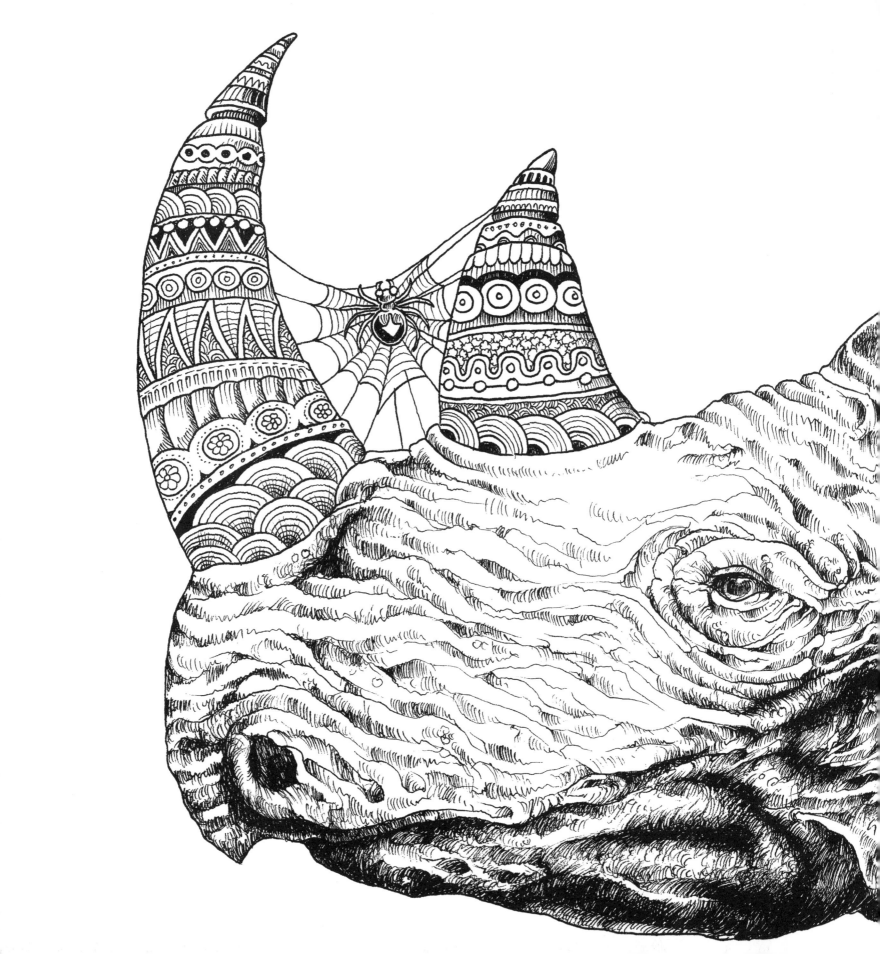

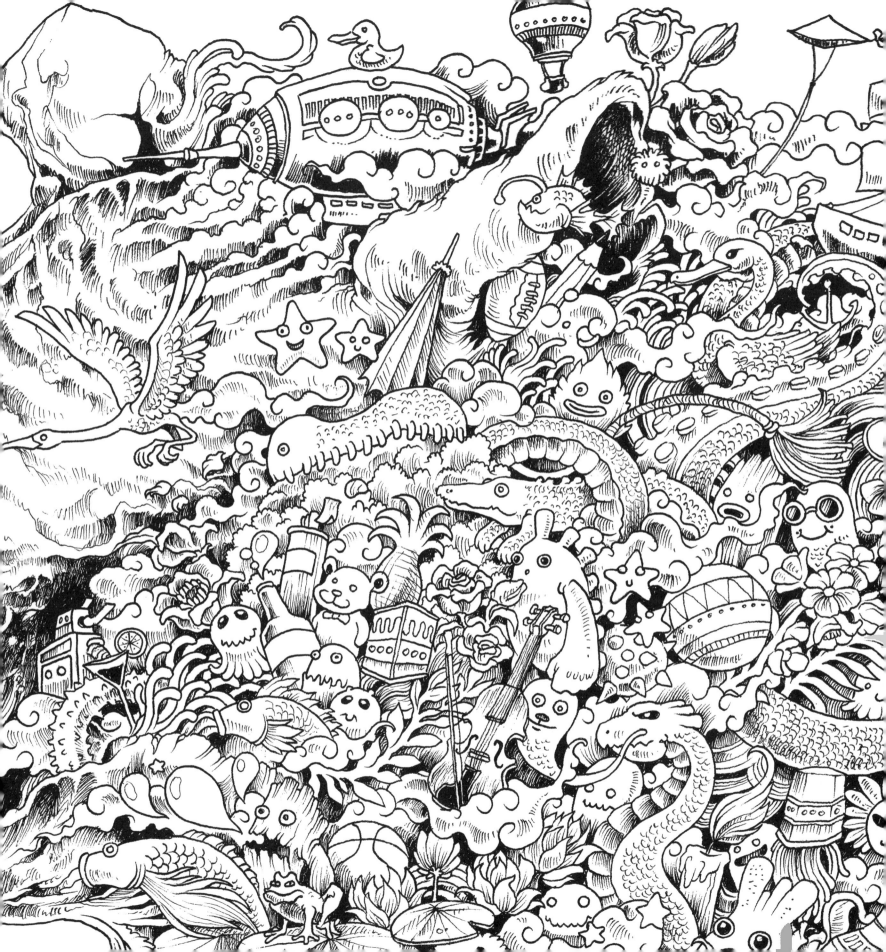

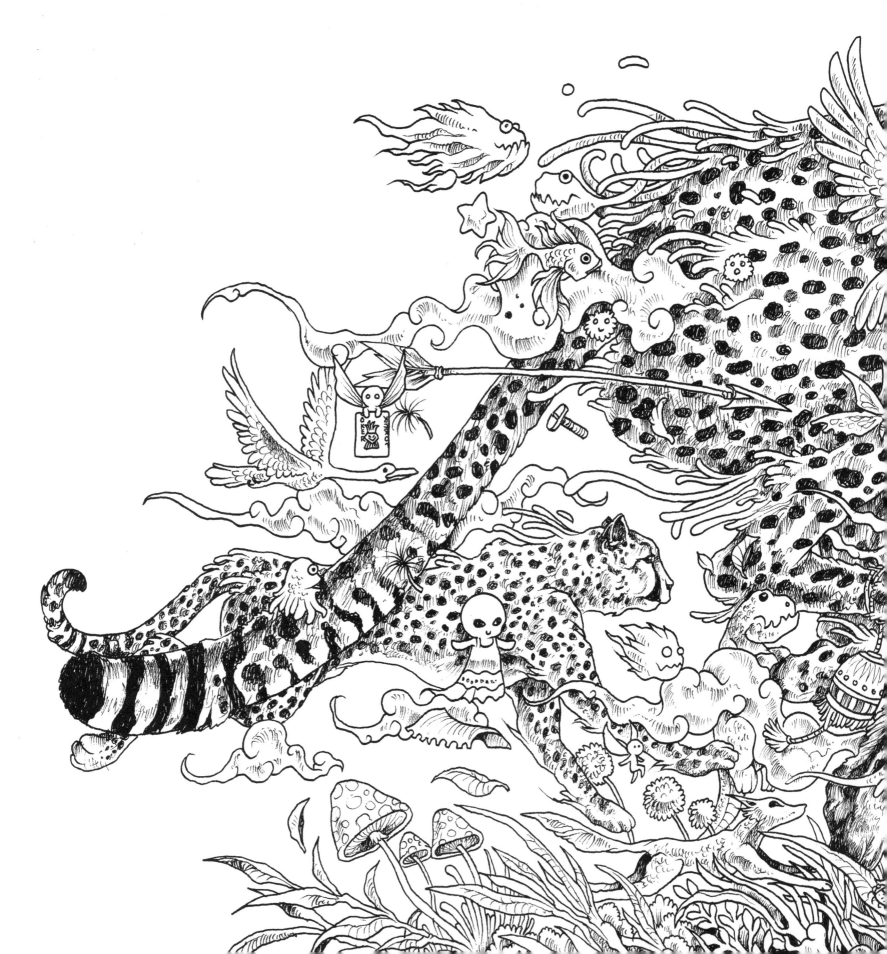

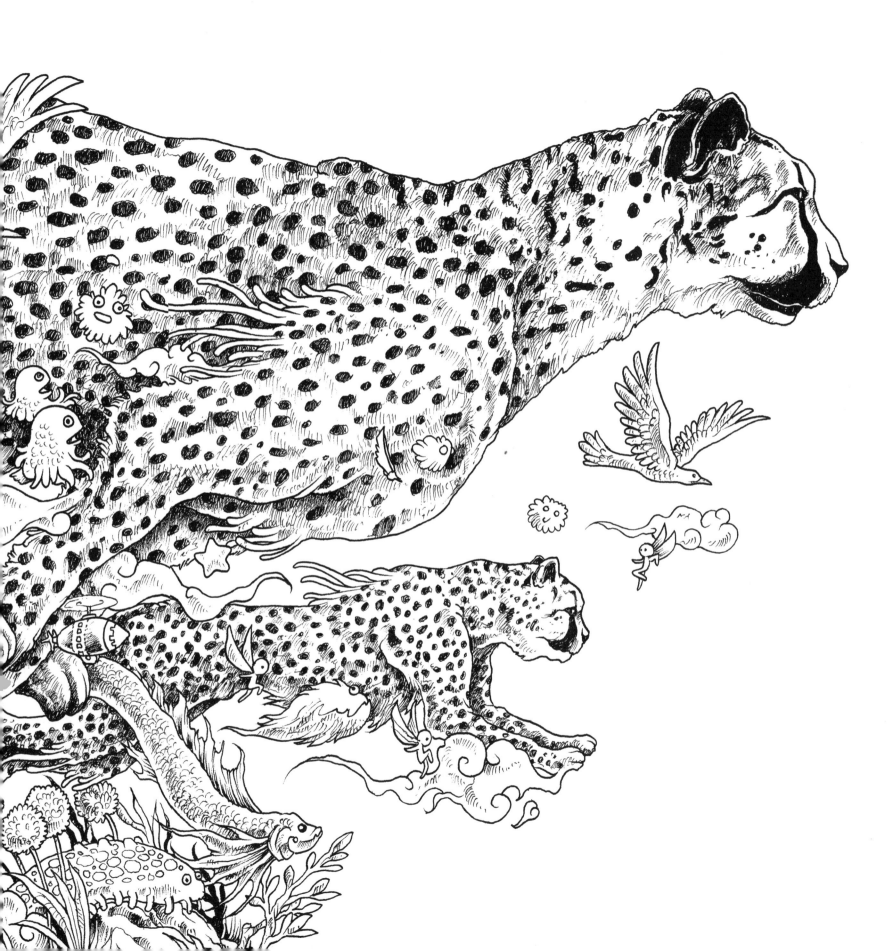

Decorate the
feathers.

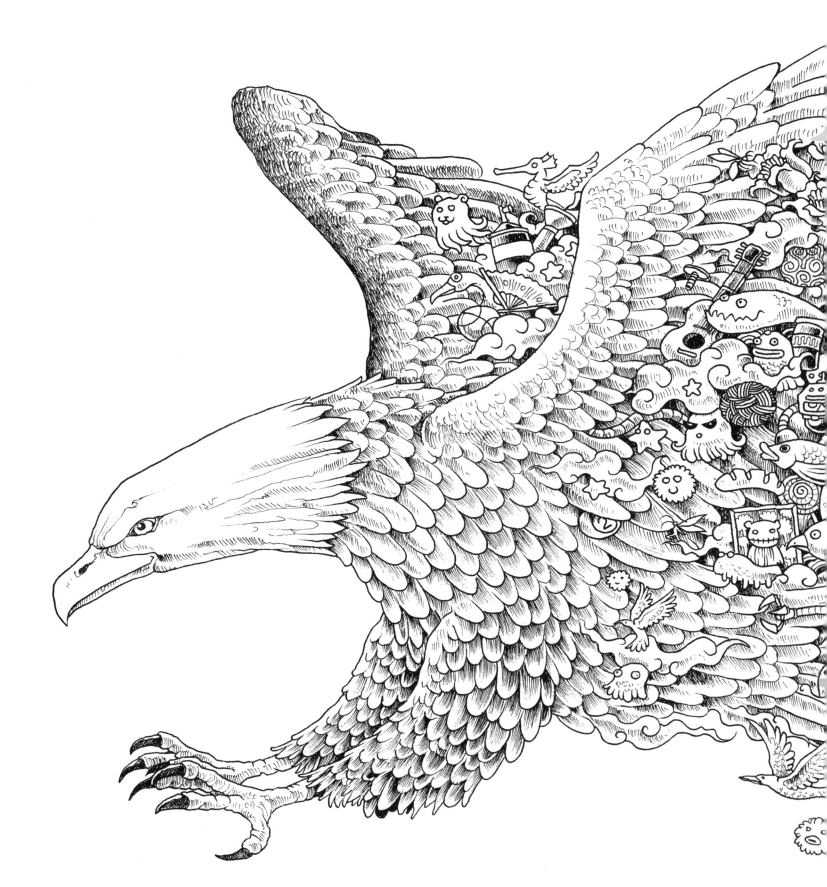

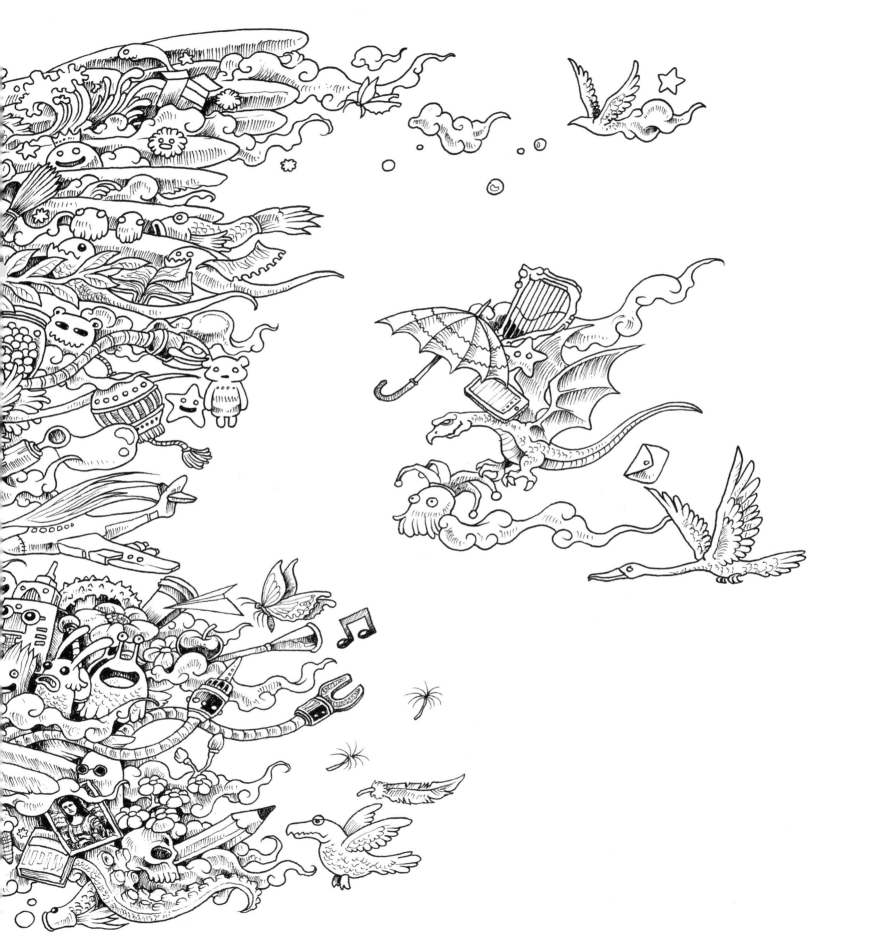

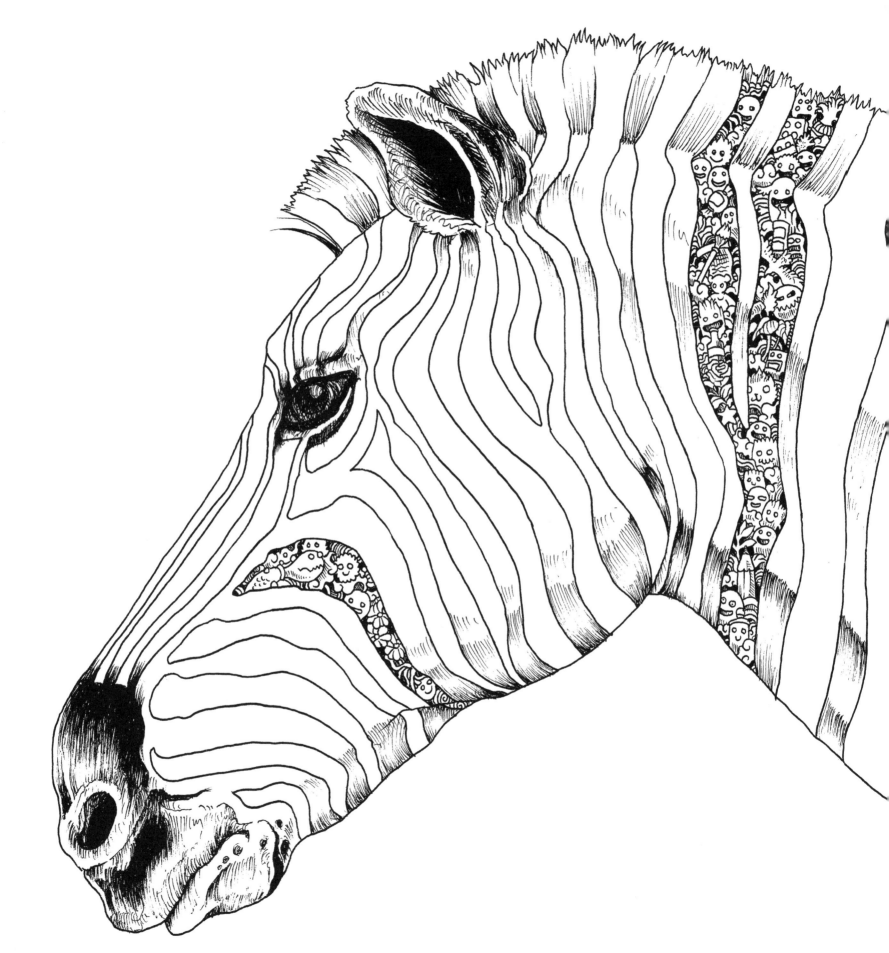

Complete the zebra's stripes.

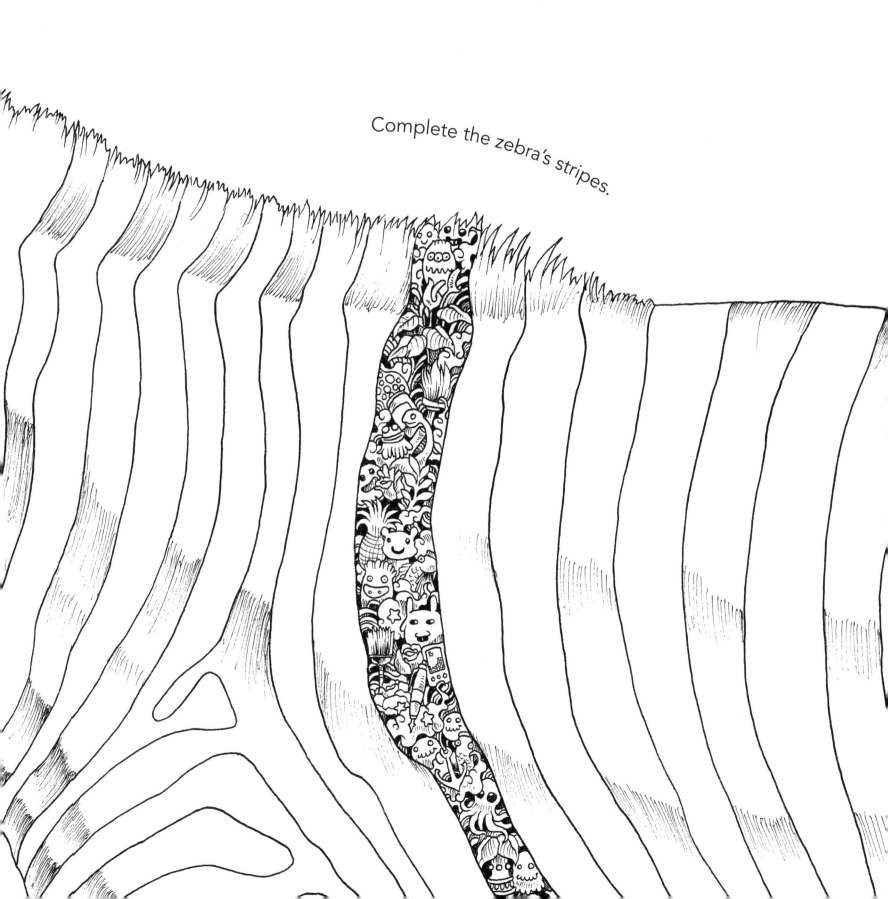

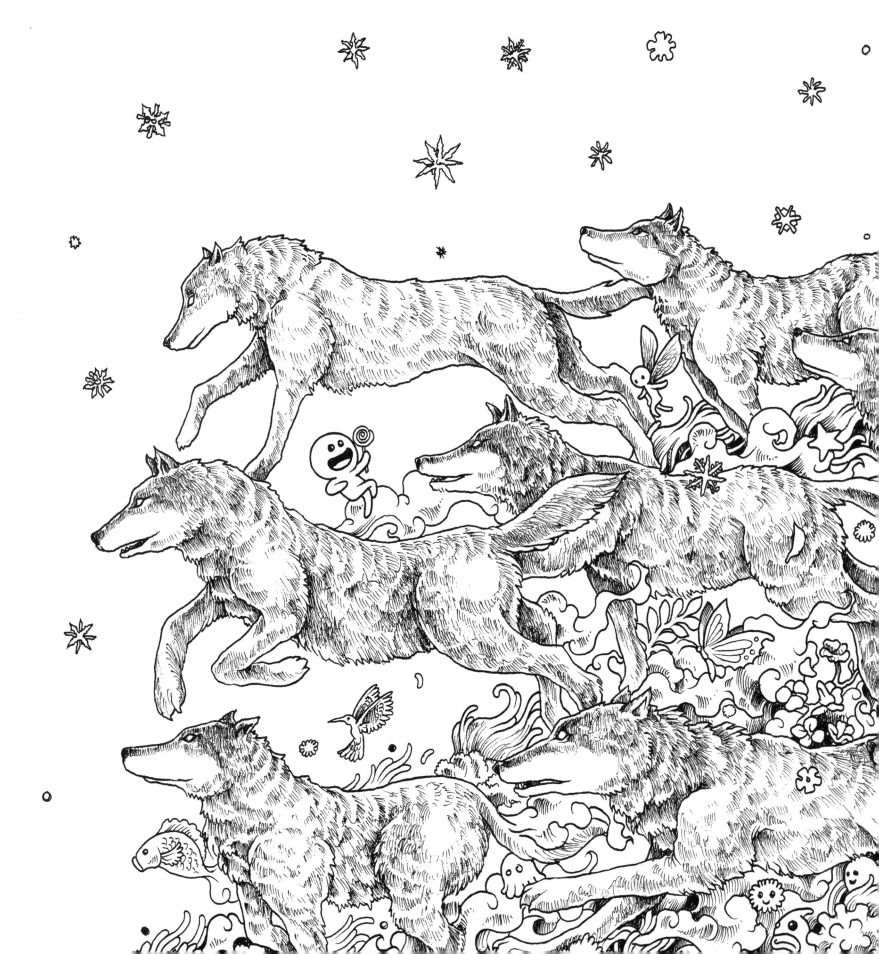

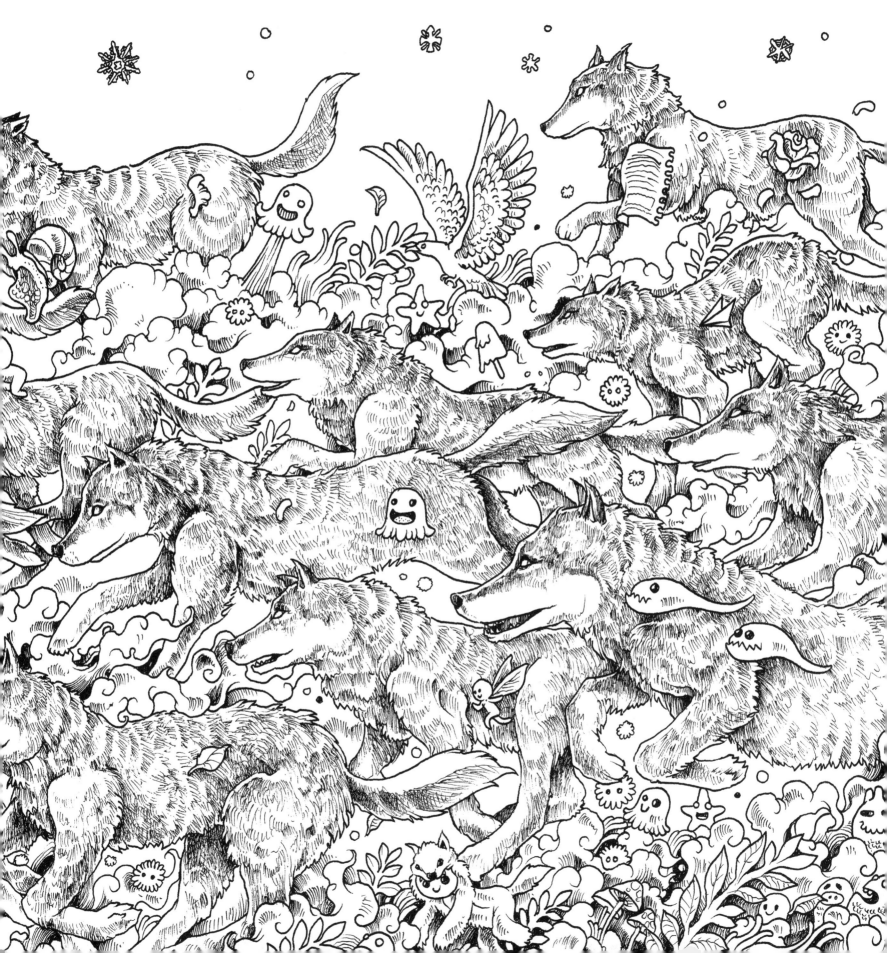

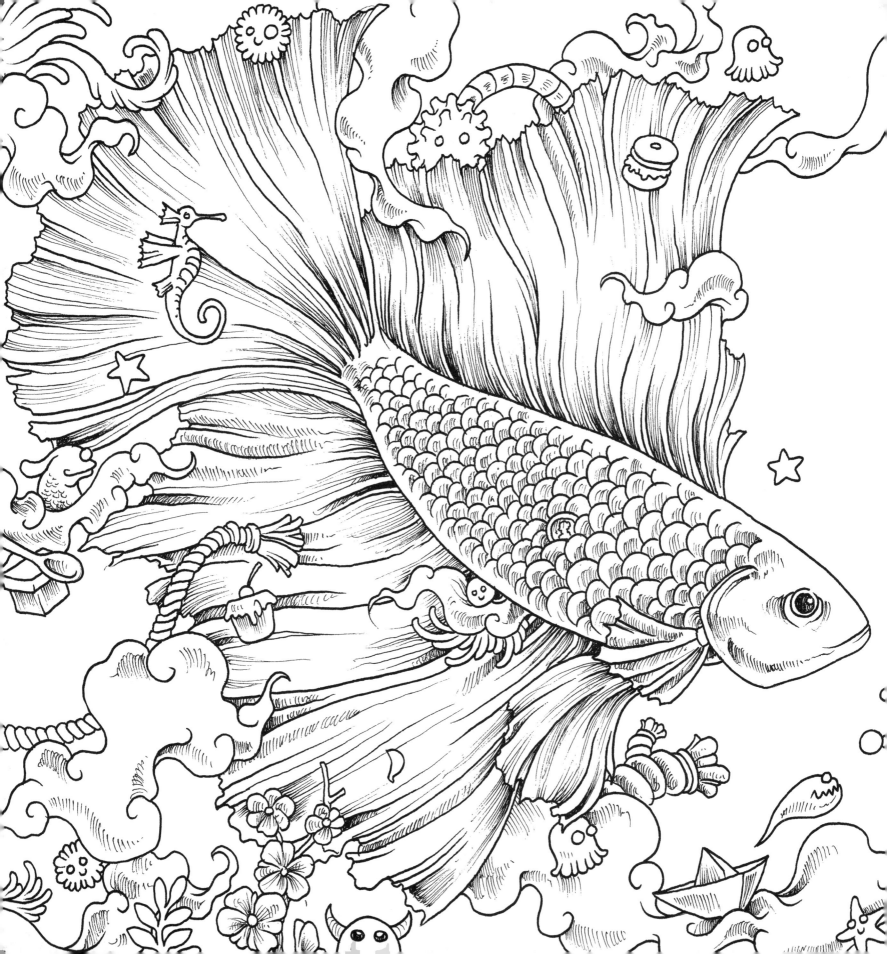

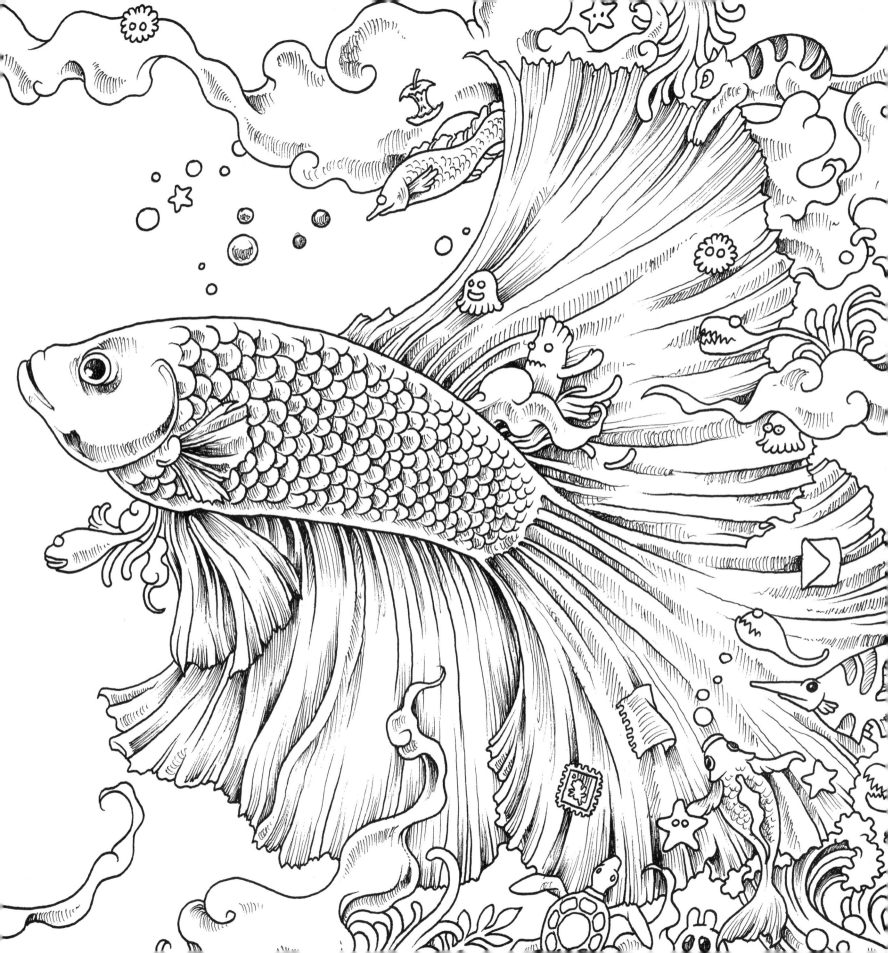

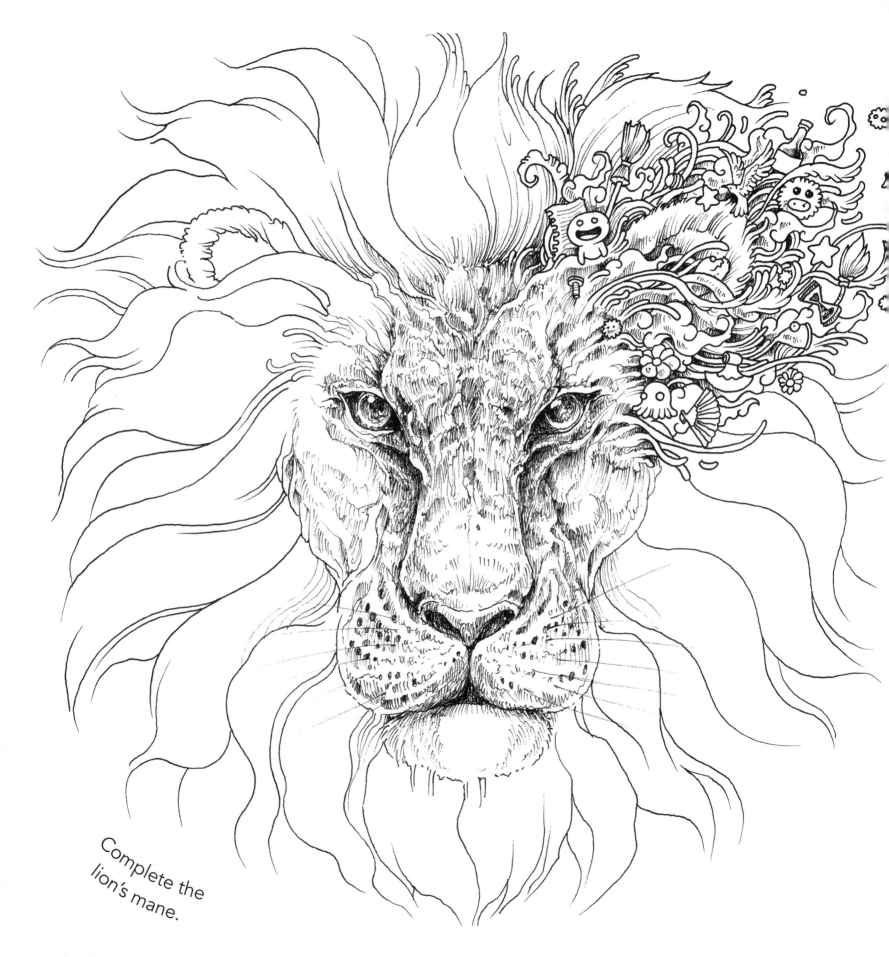

Complete the
lion's mane.

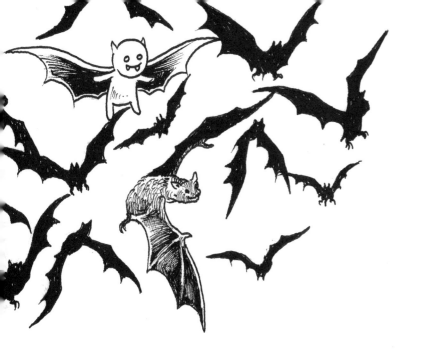

Fill the page with bats.

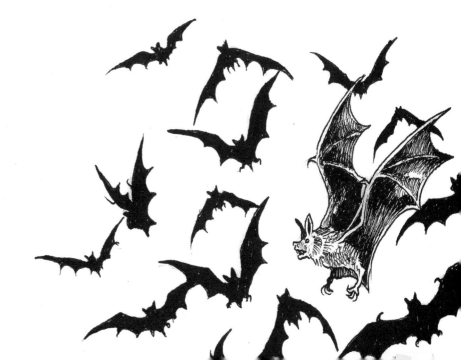

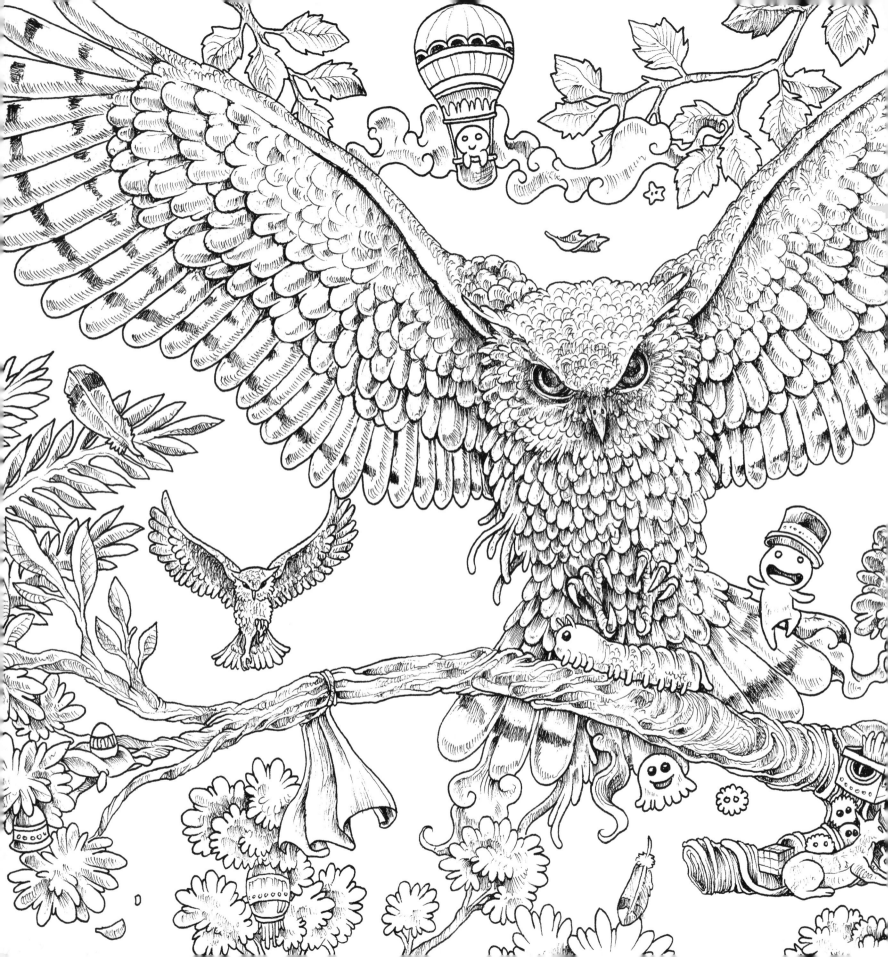

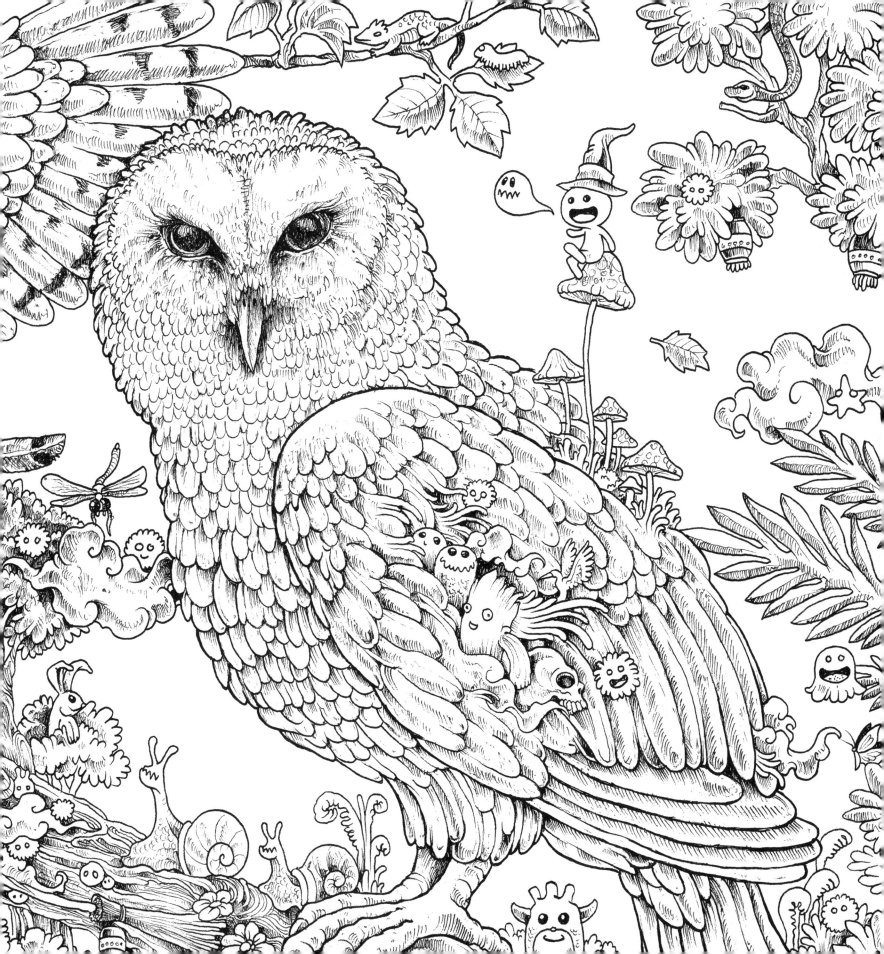

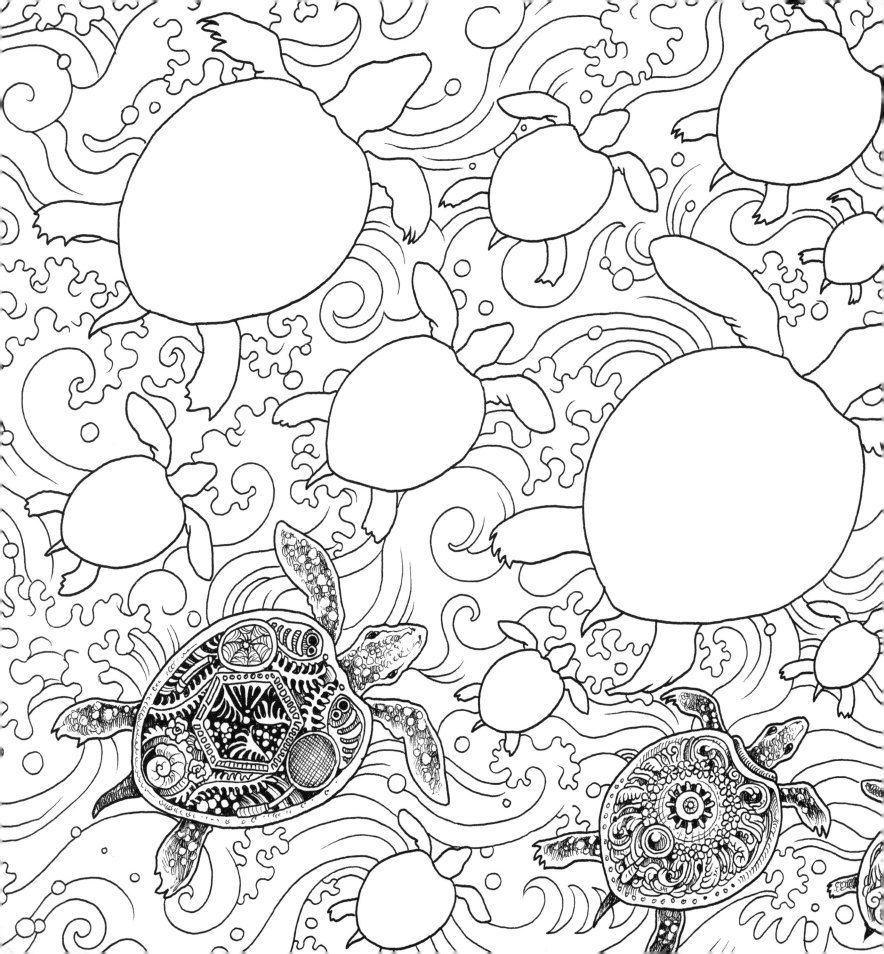

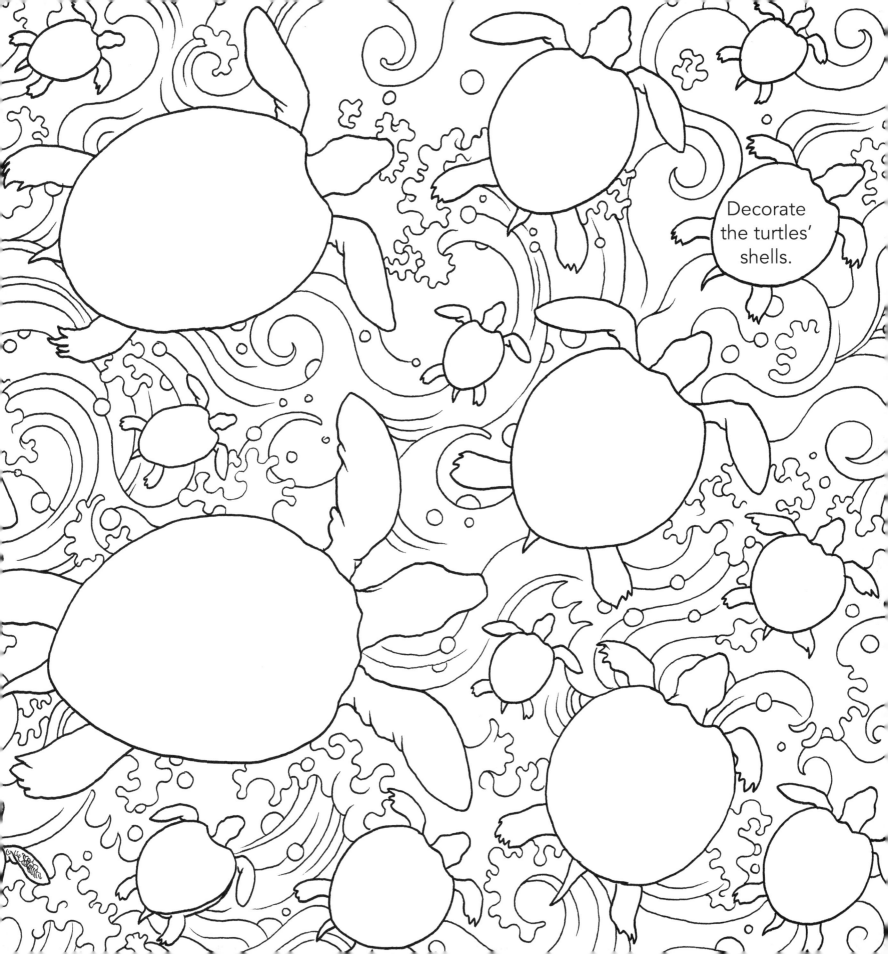

Decorate the turtles' shells.

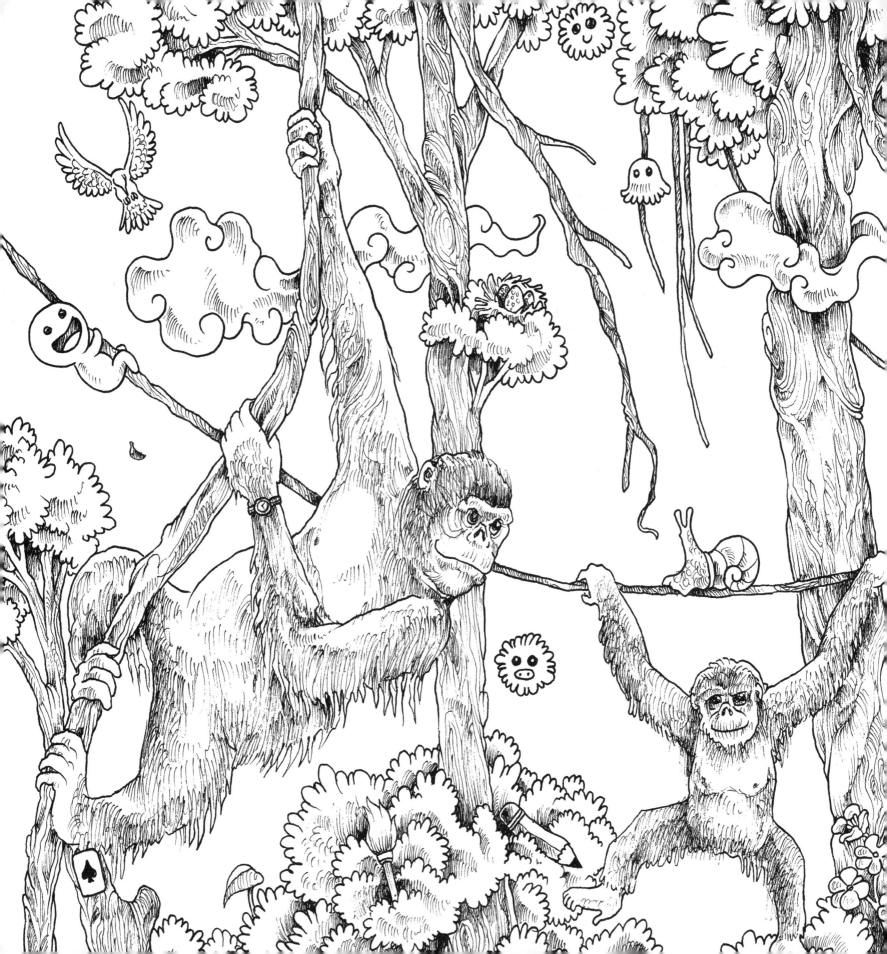

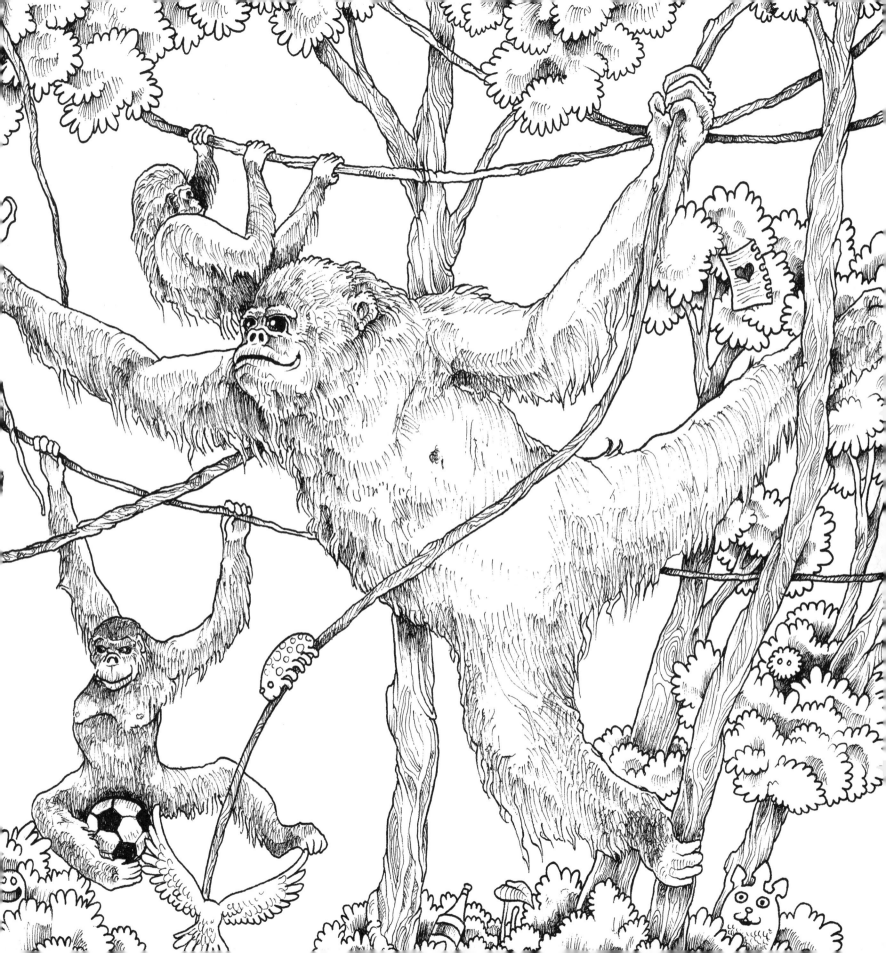

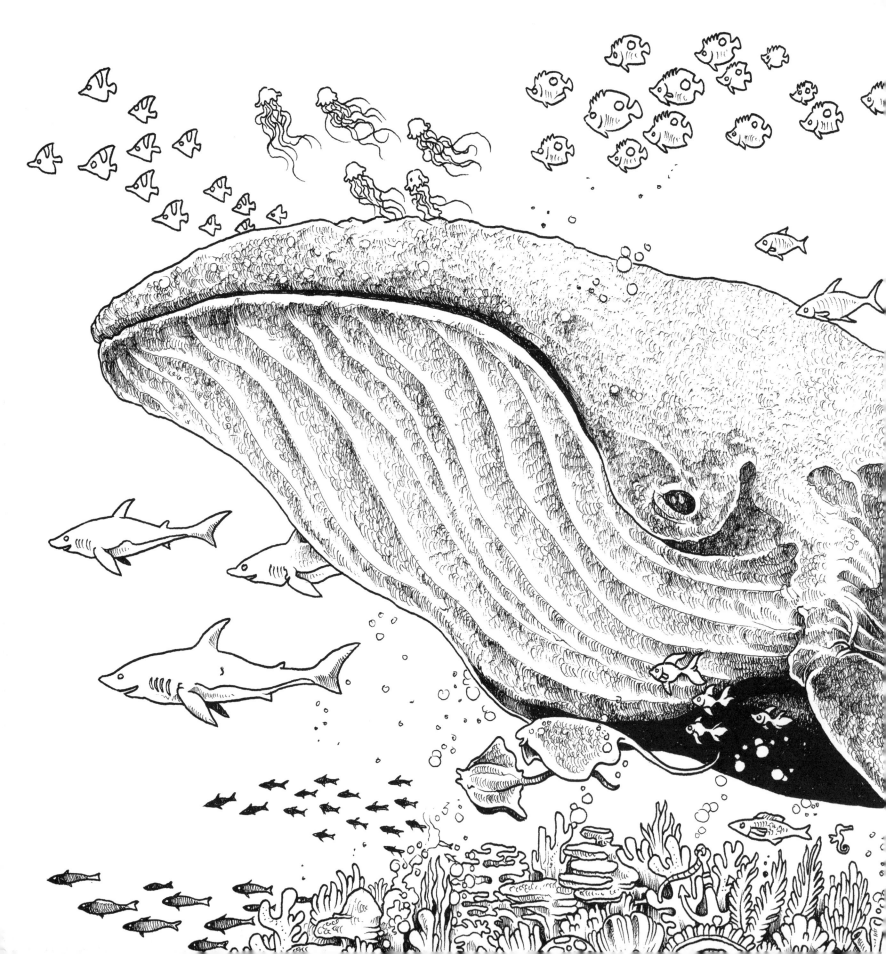

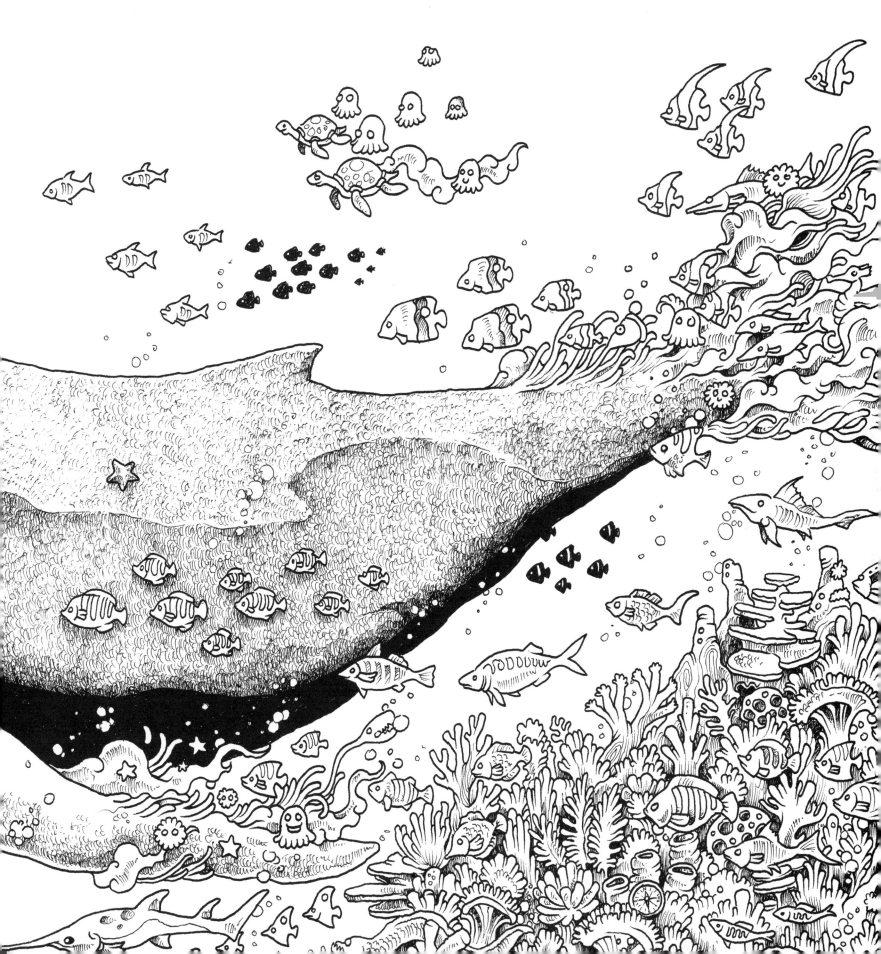

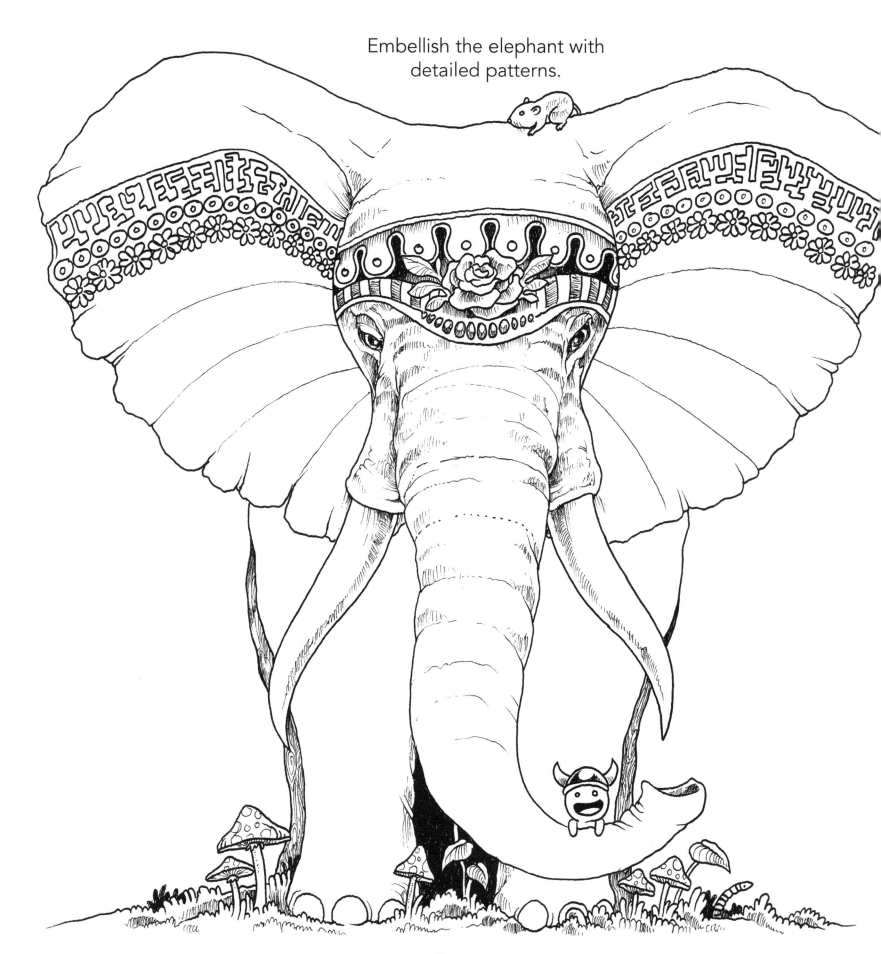

Embellish the elephant with detailed patterns.

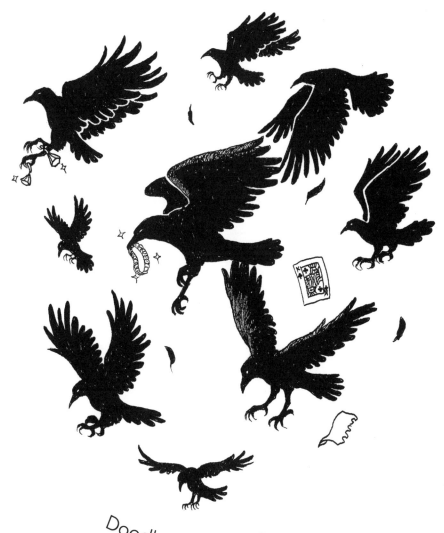

Doodle more crows.

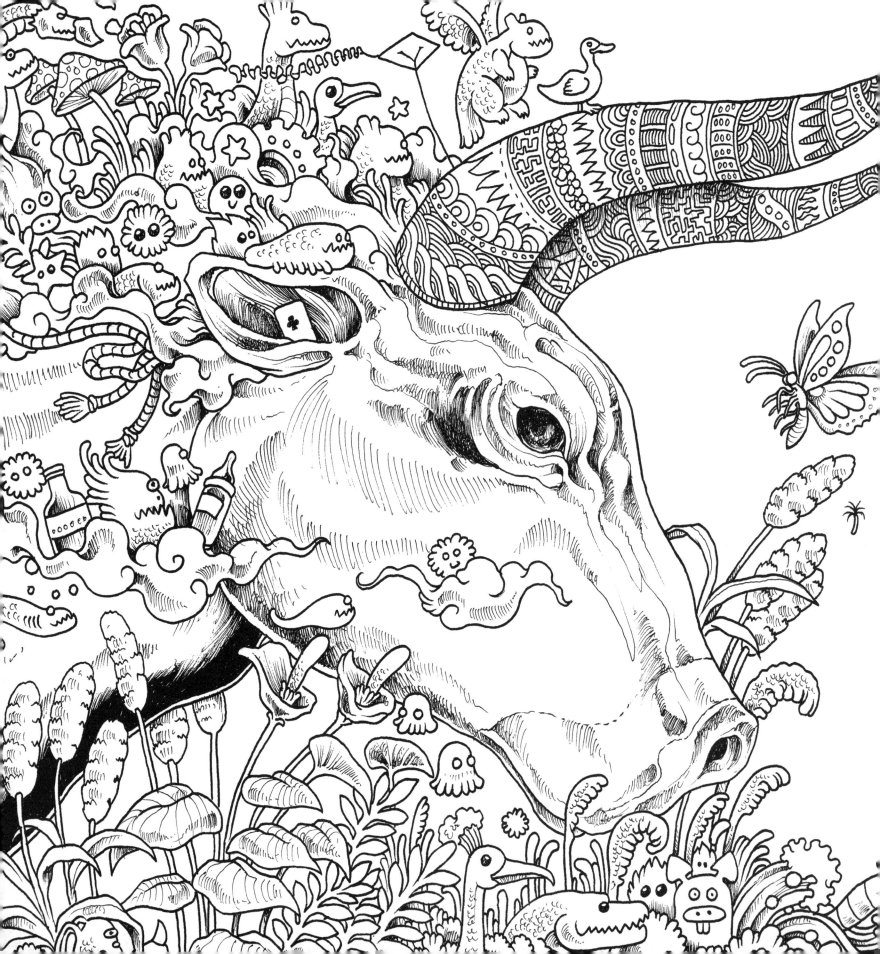

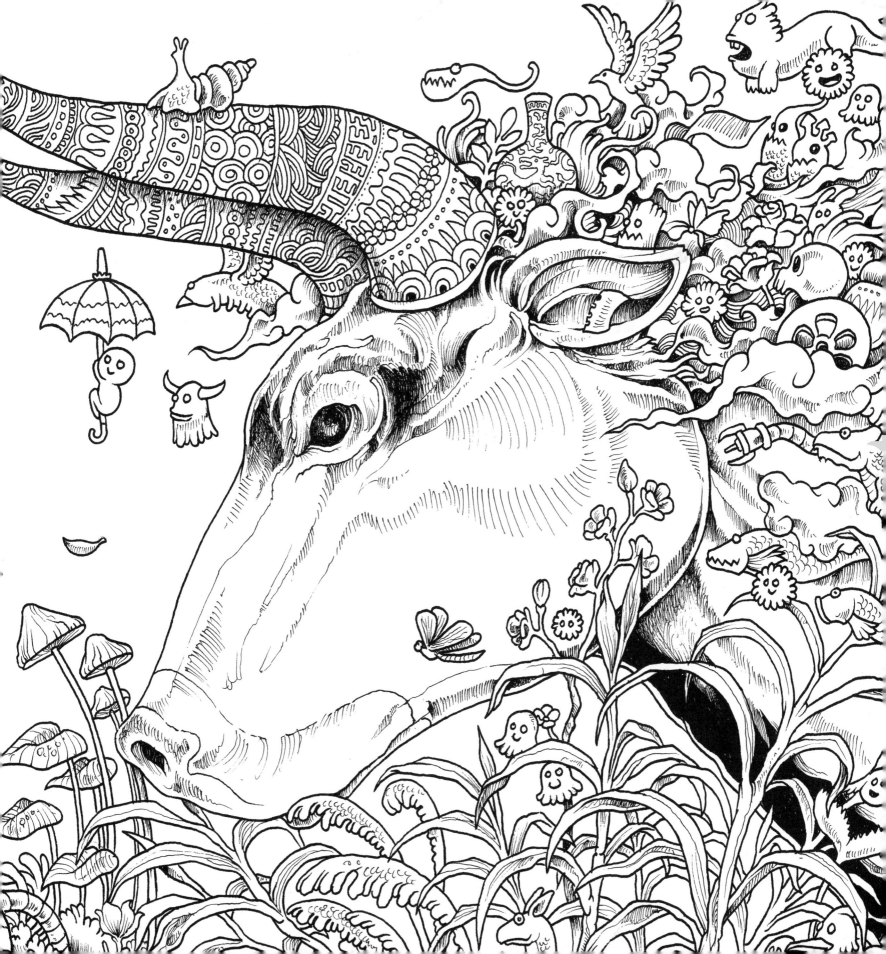

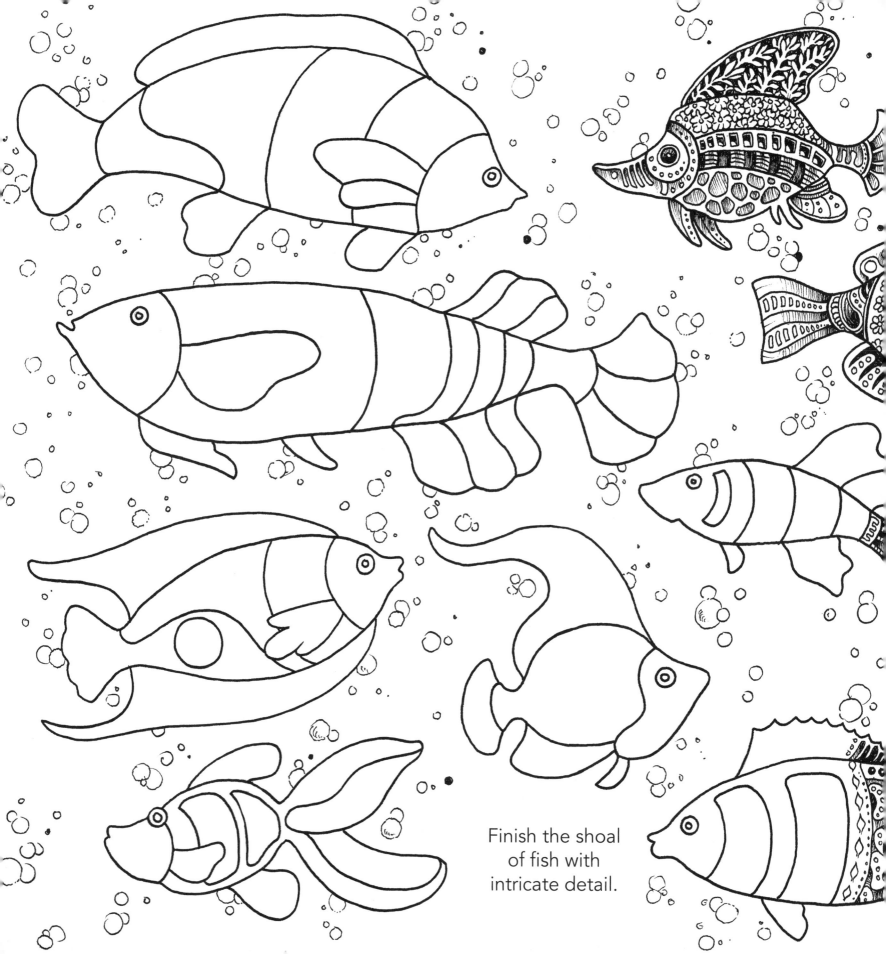

Finish the shoal
of fish with
intricate detail.

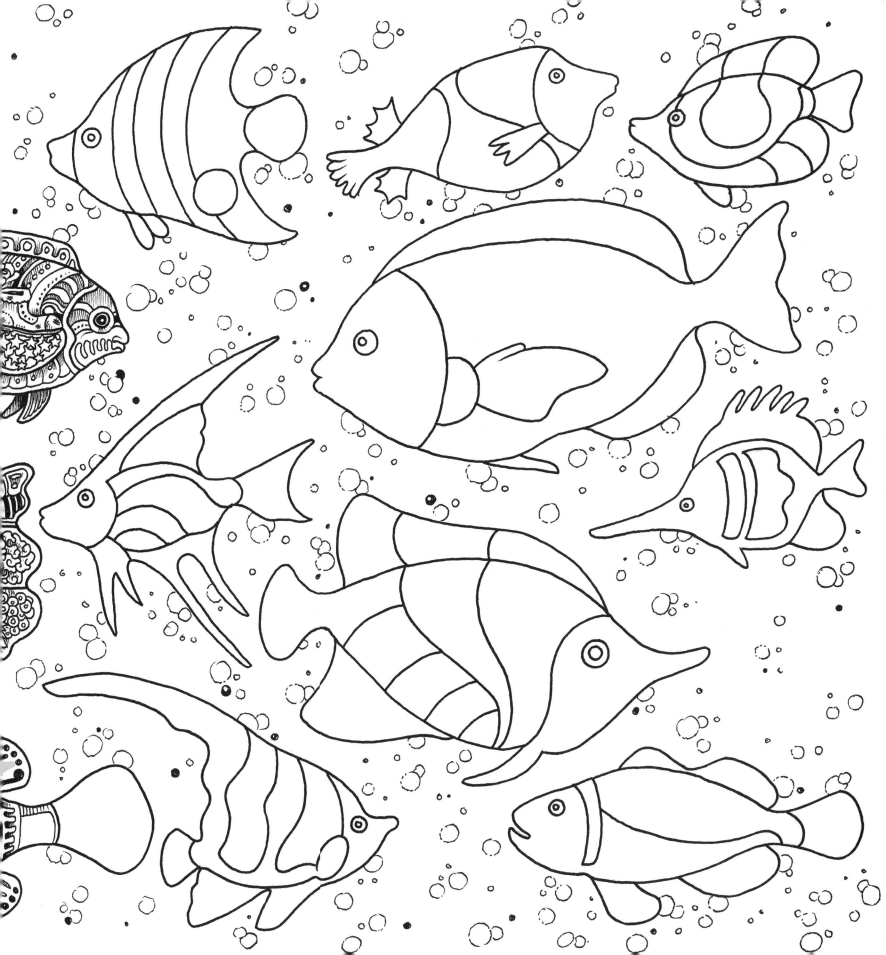

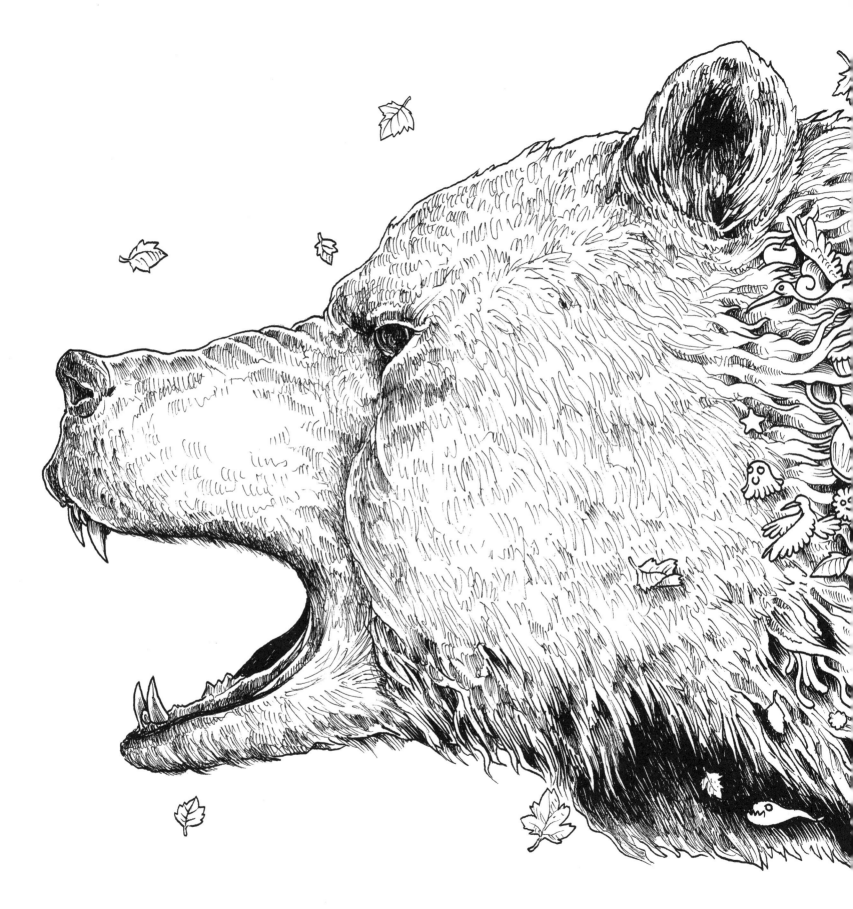

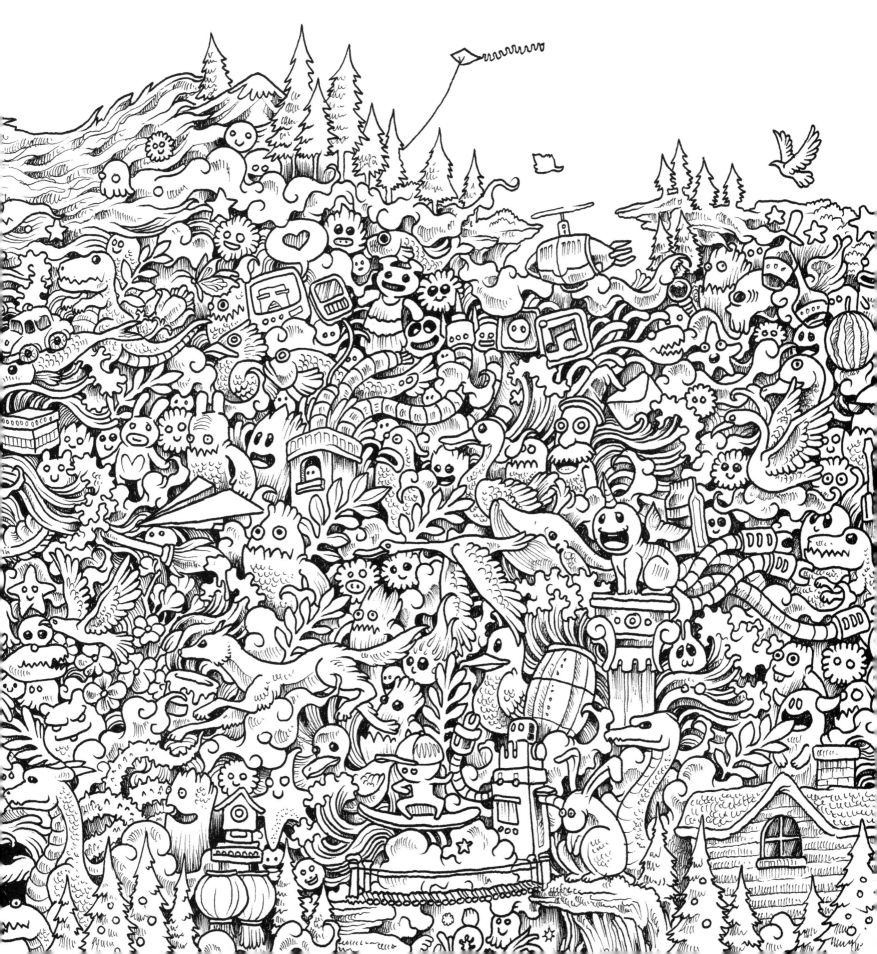

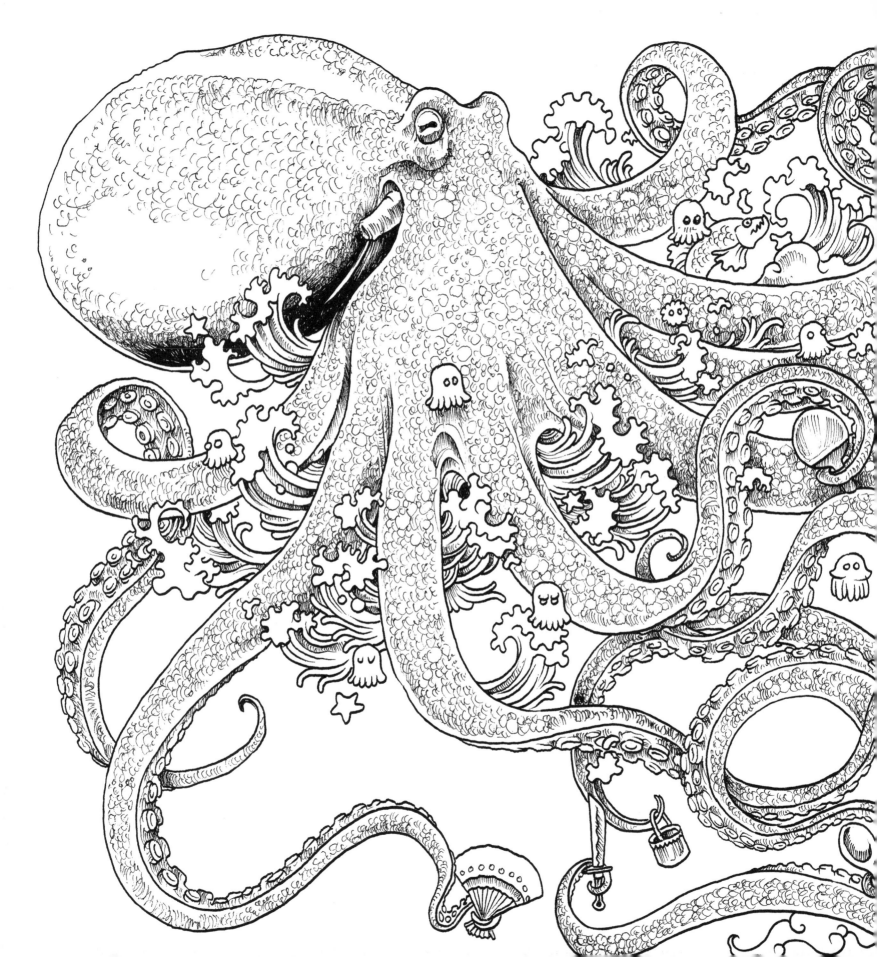

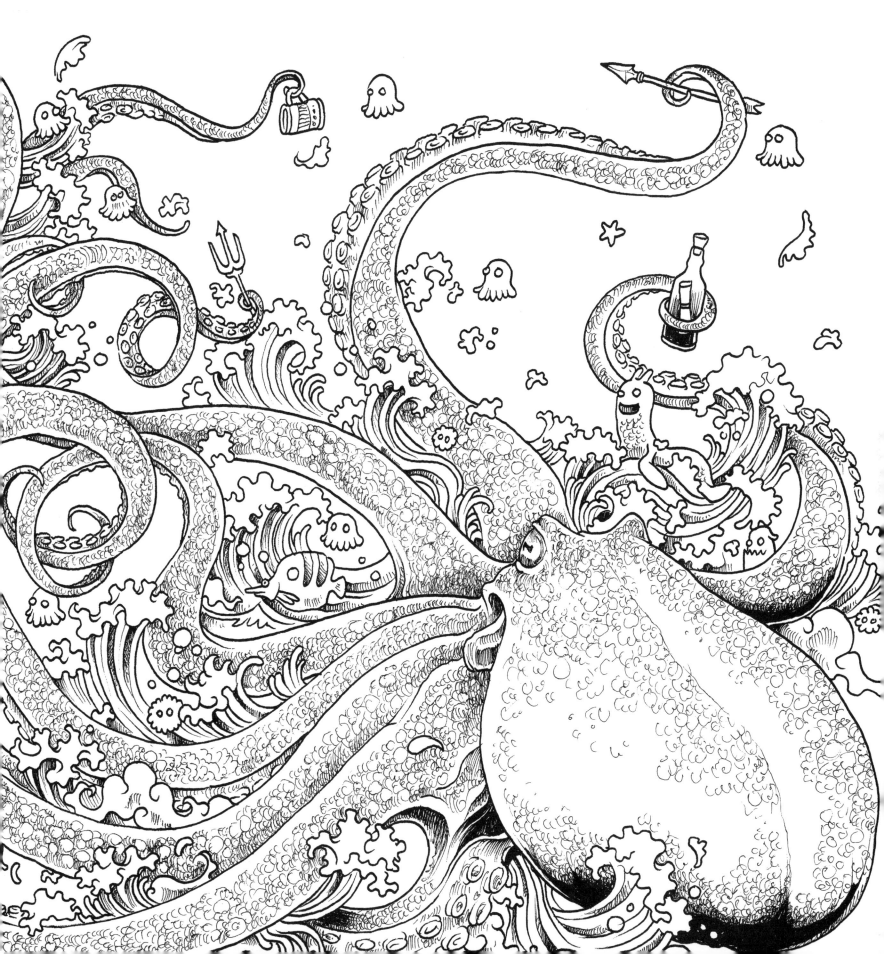

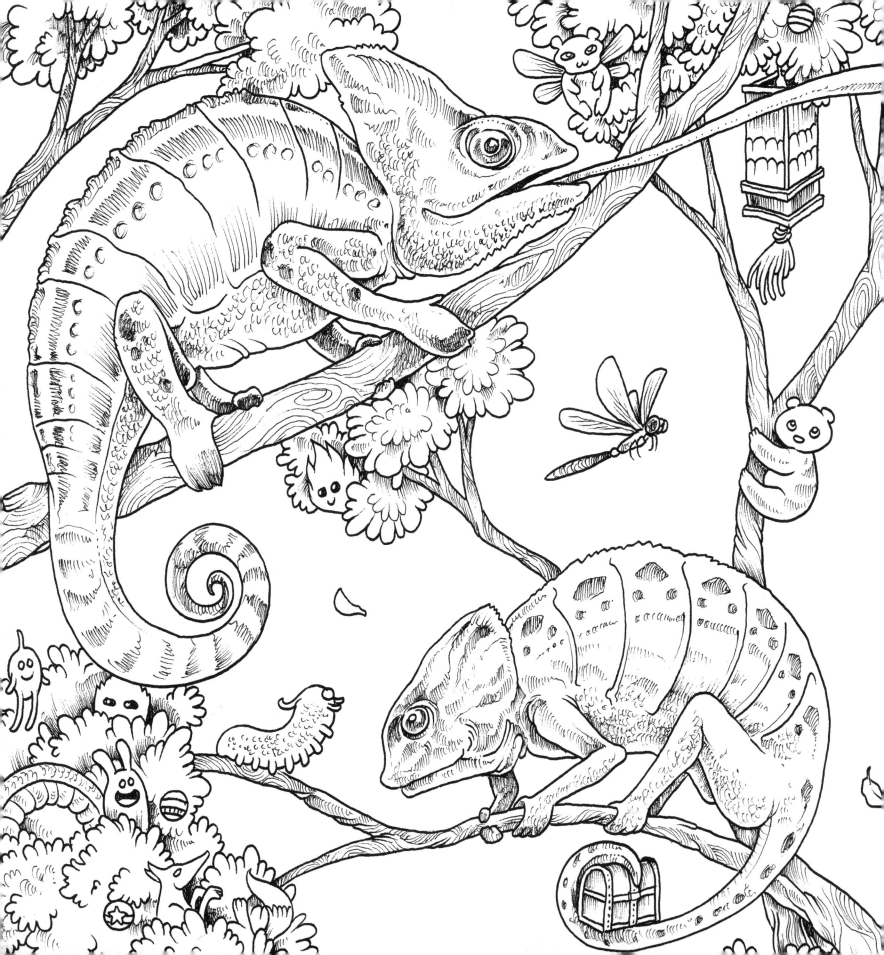

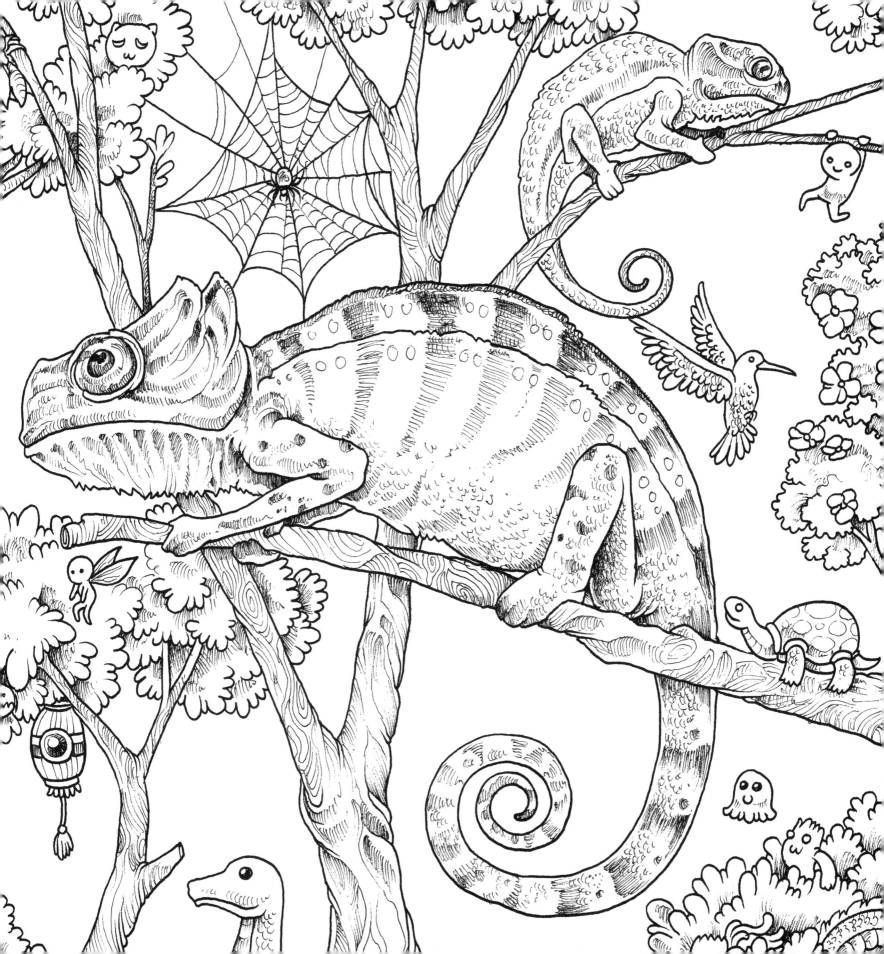

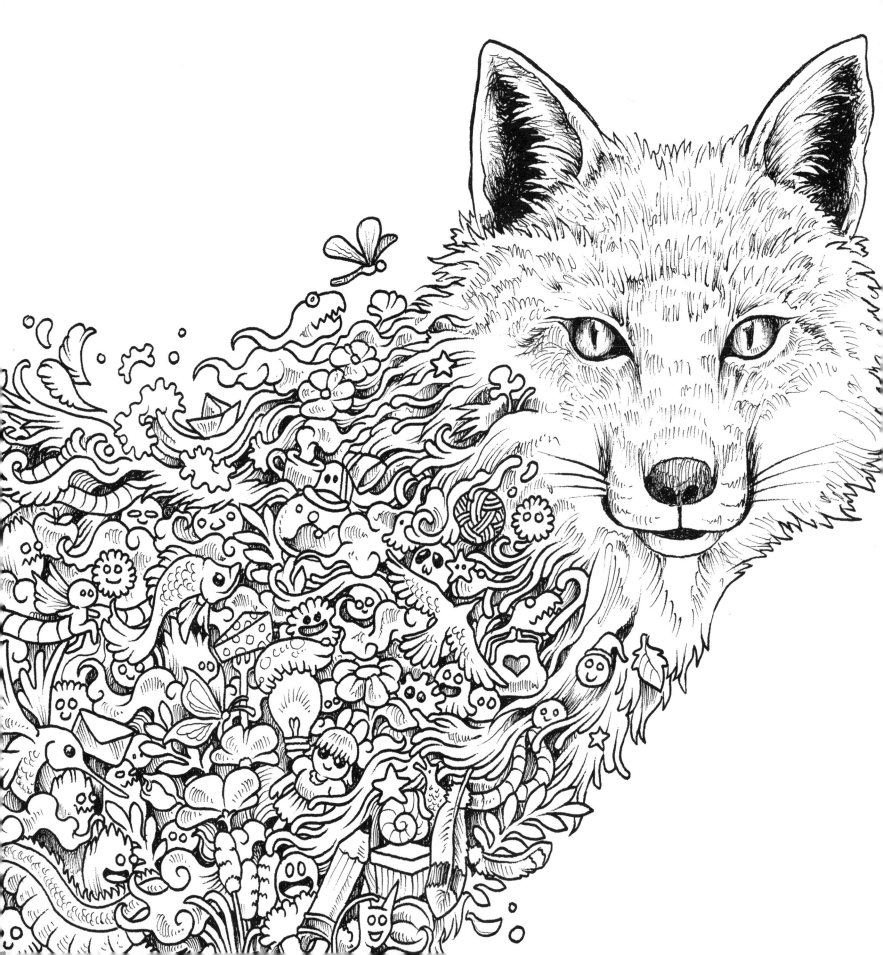

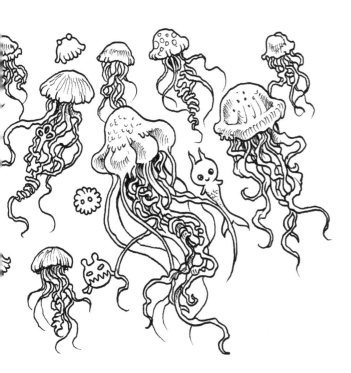

Draw more jellyfish to fill the page.

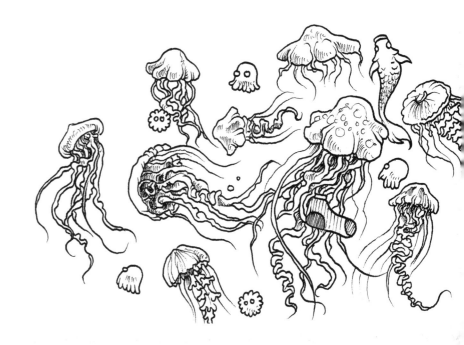

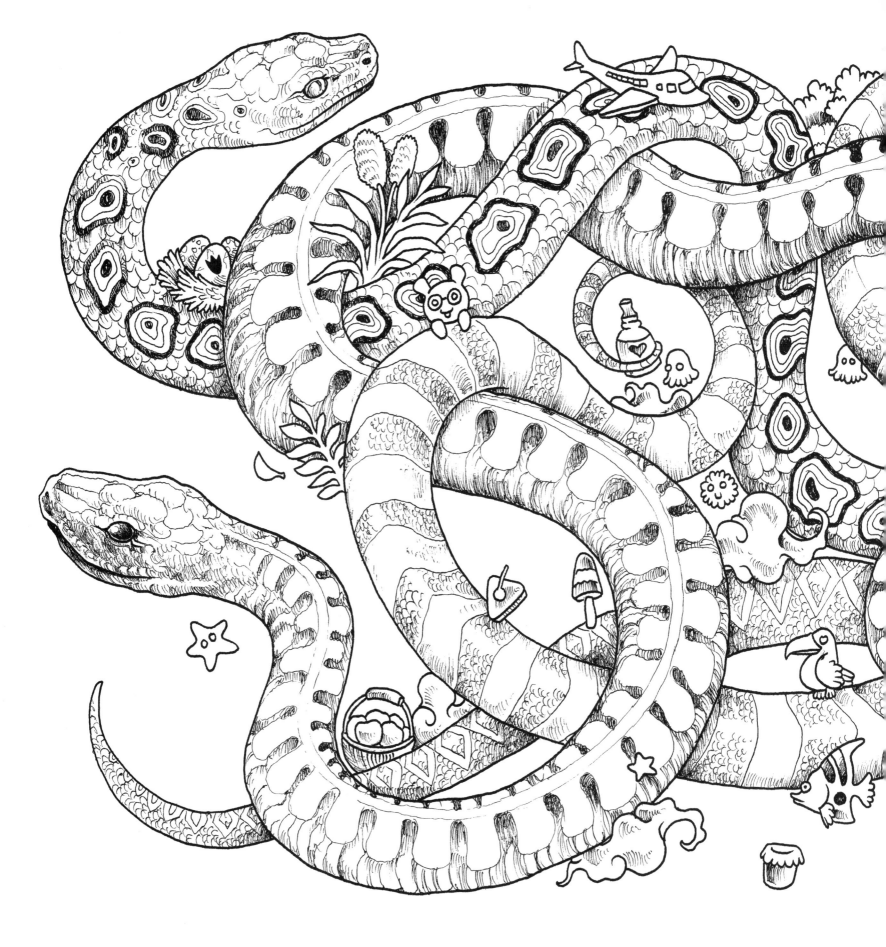

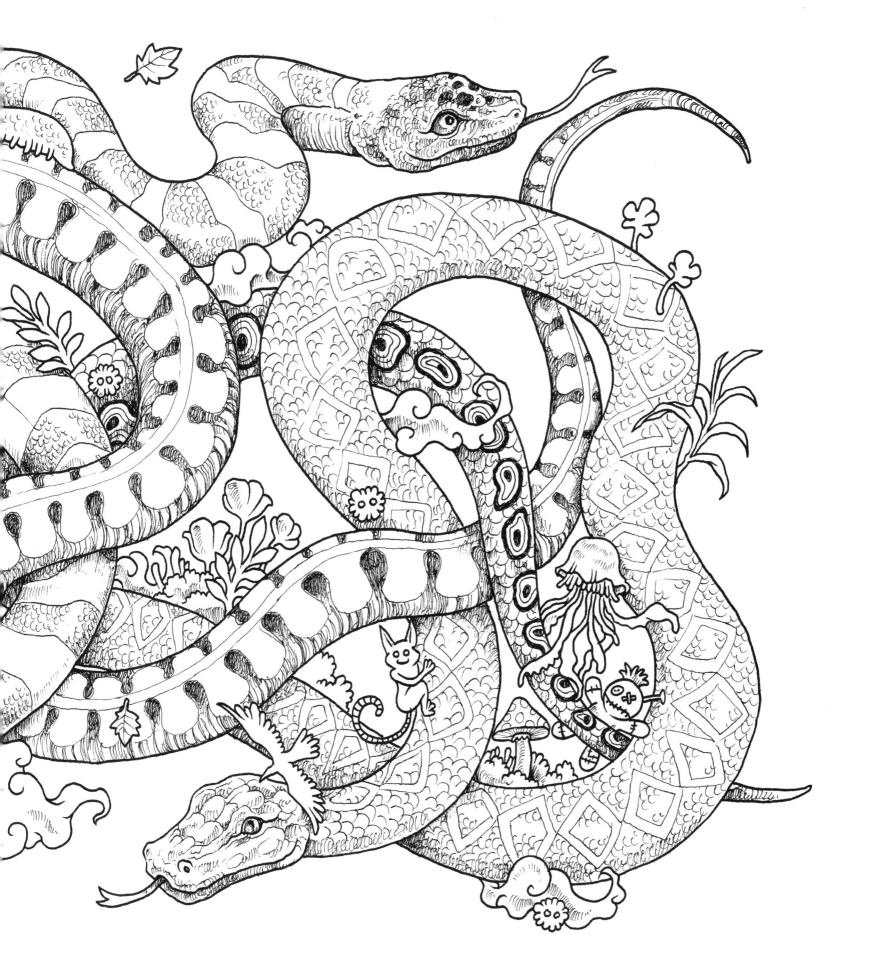

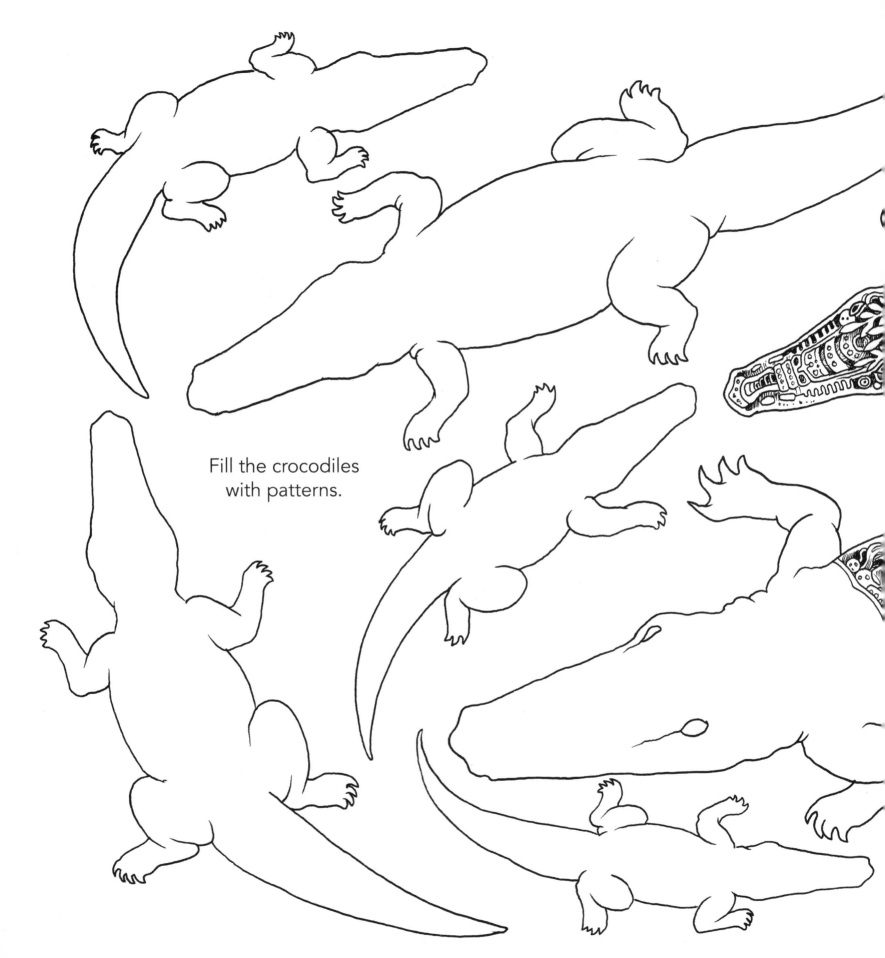

Fill the crocodiles
with patterns.

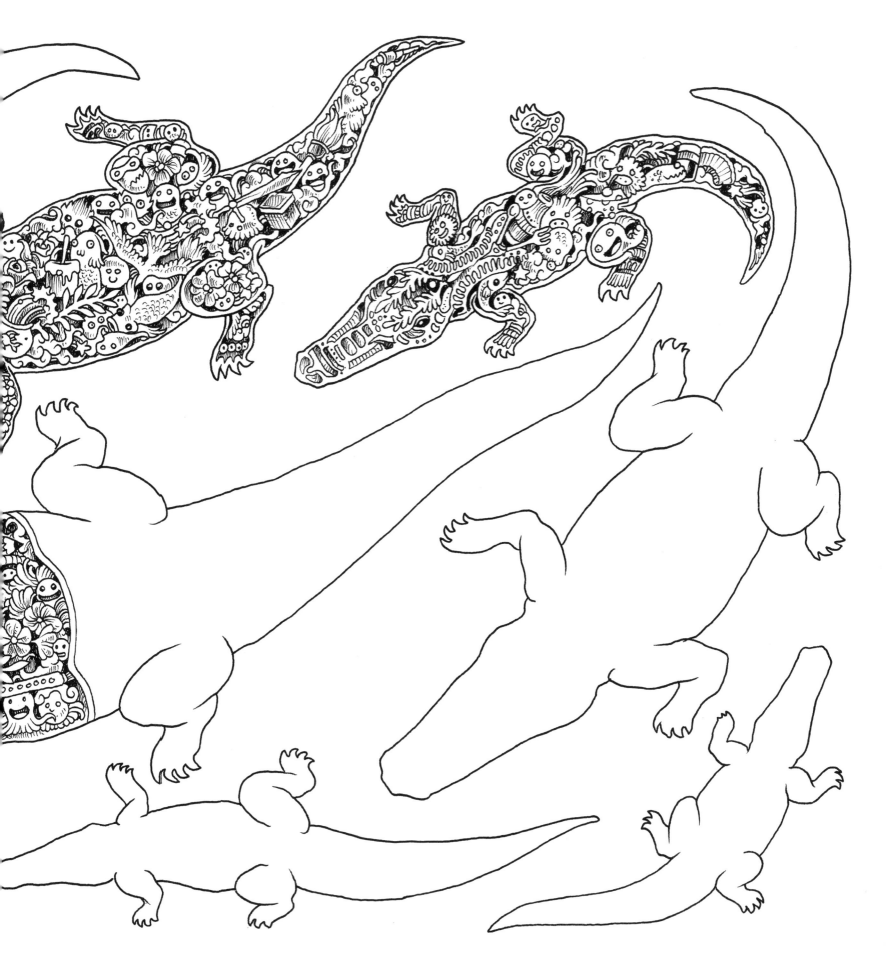

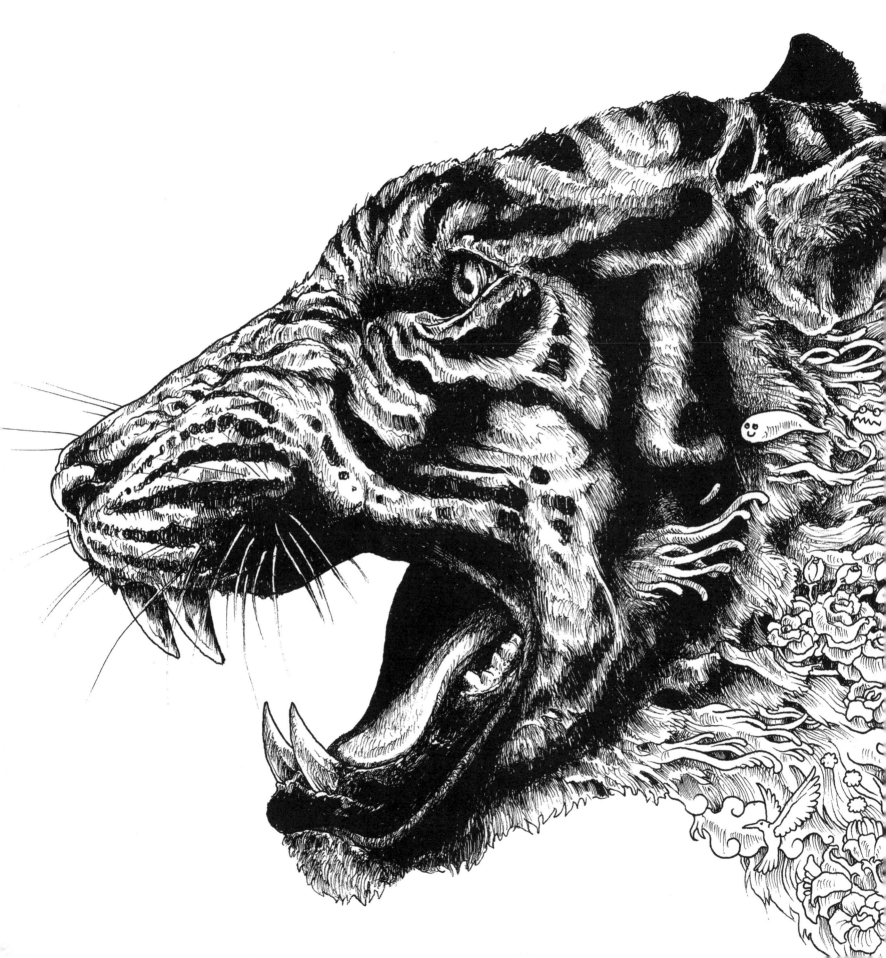

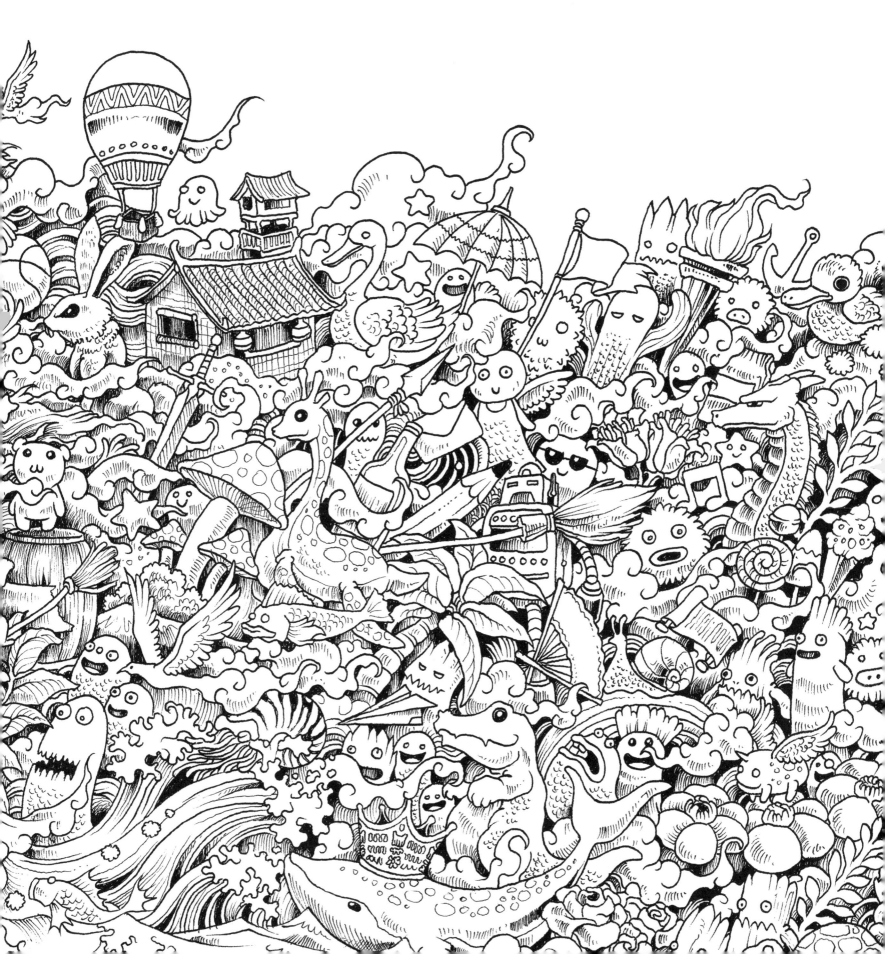

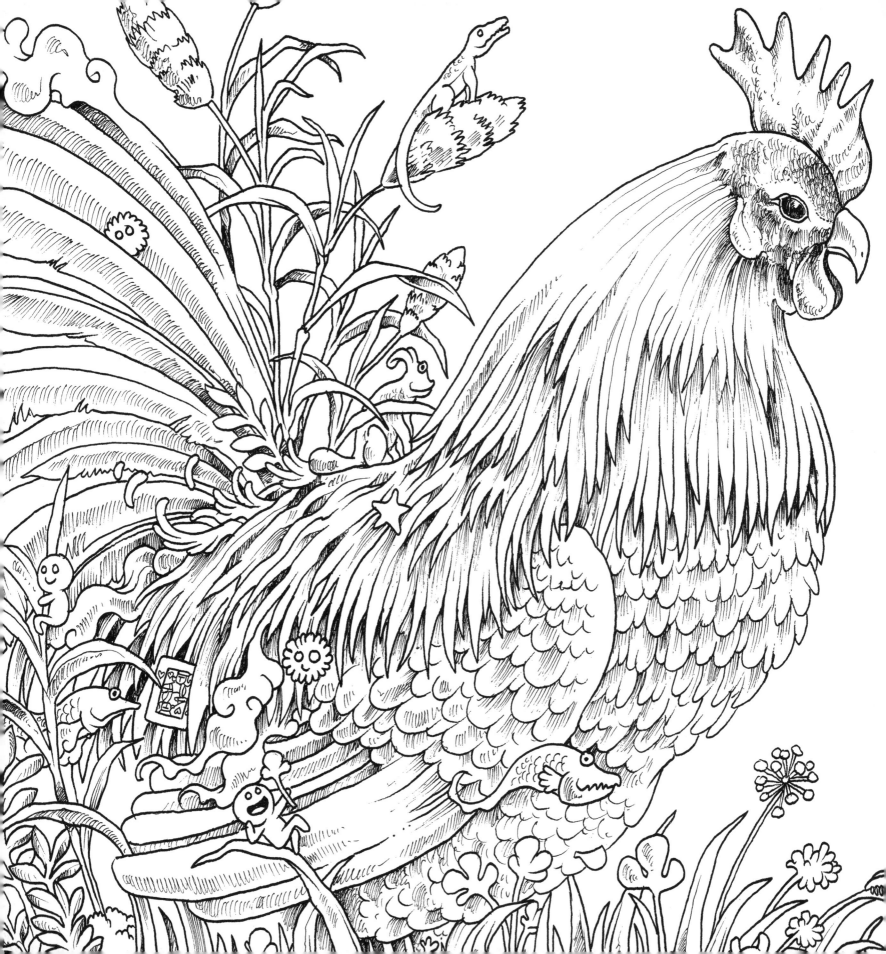

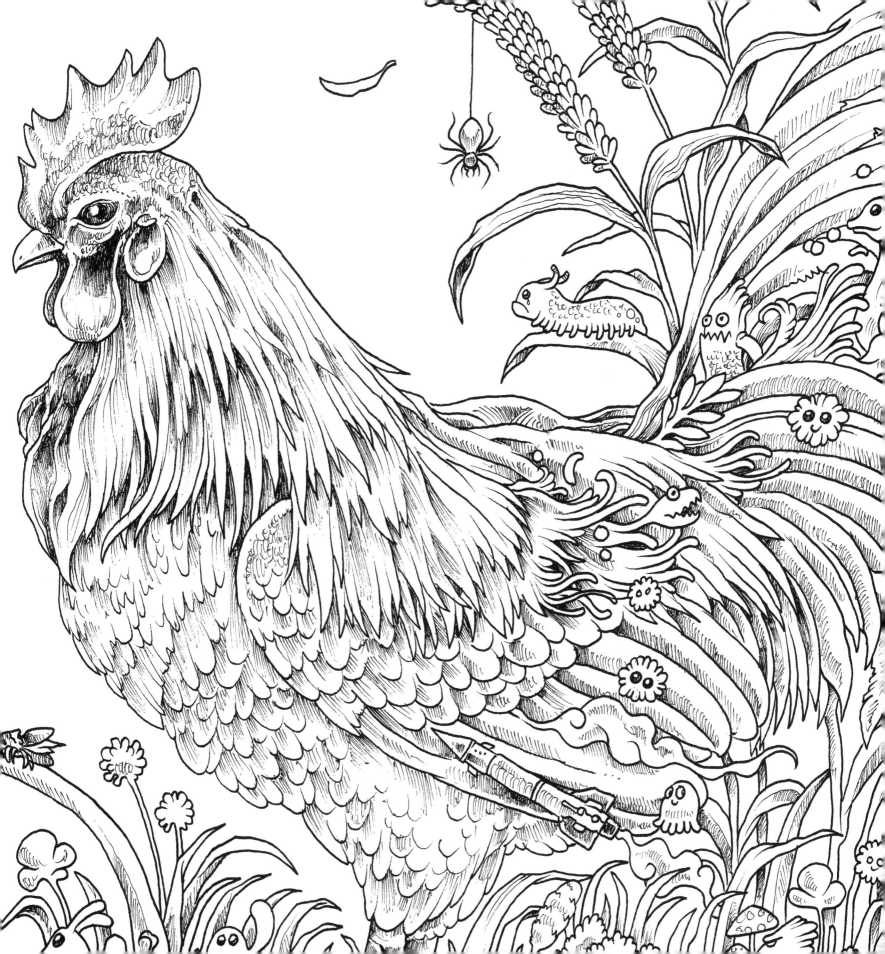

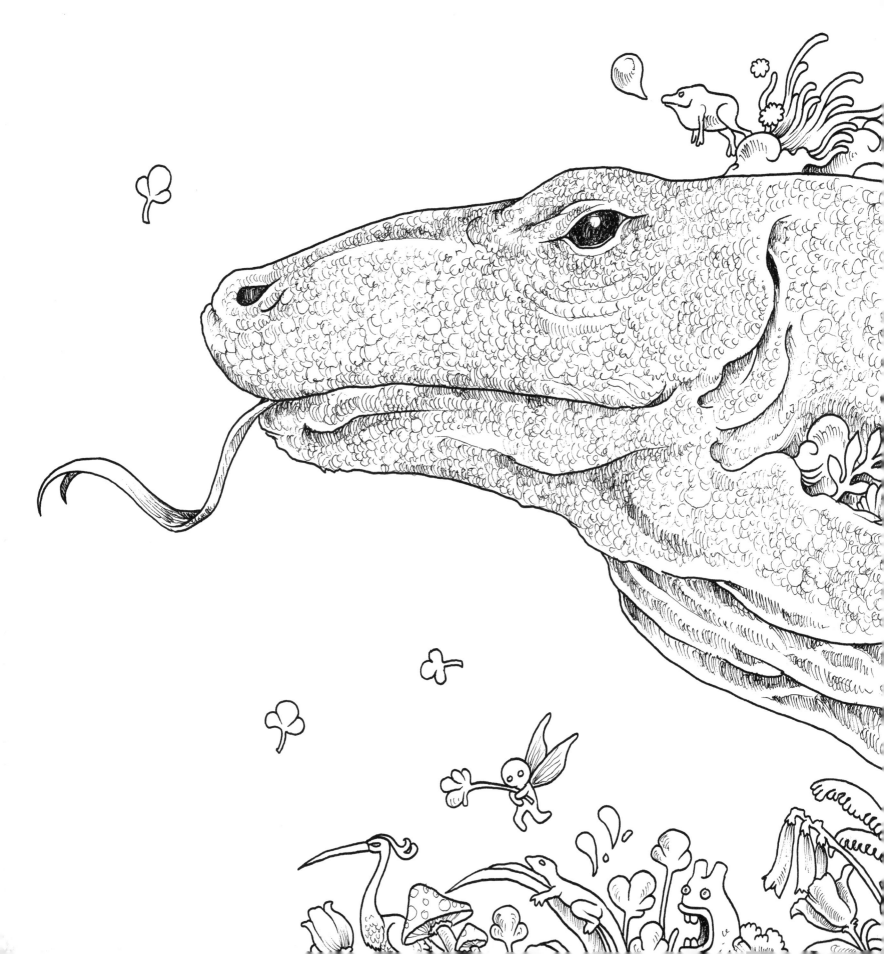

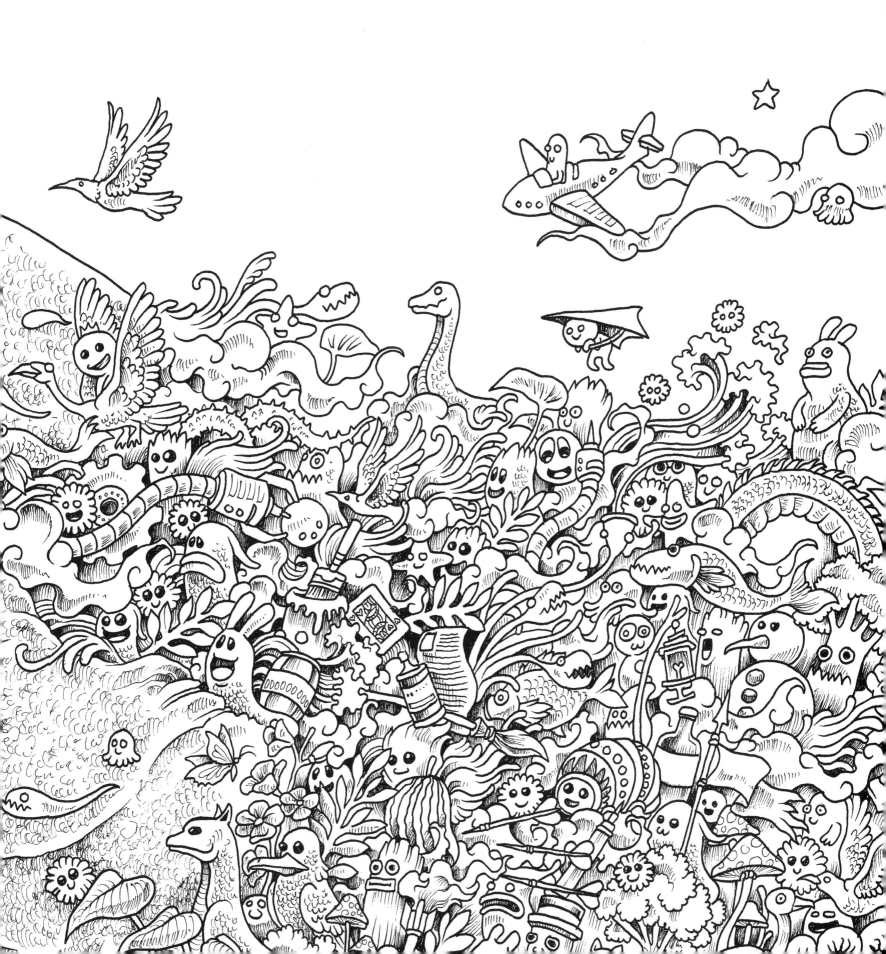

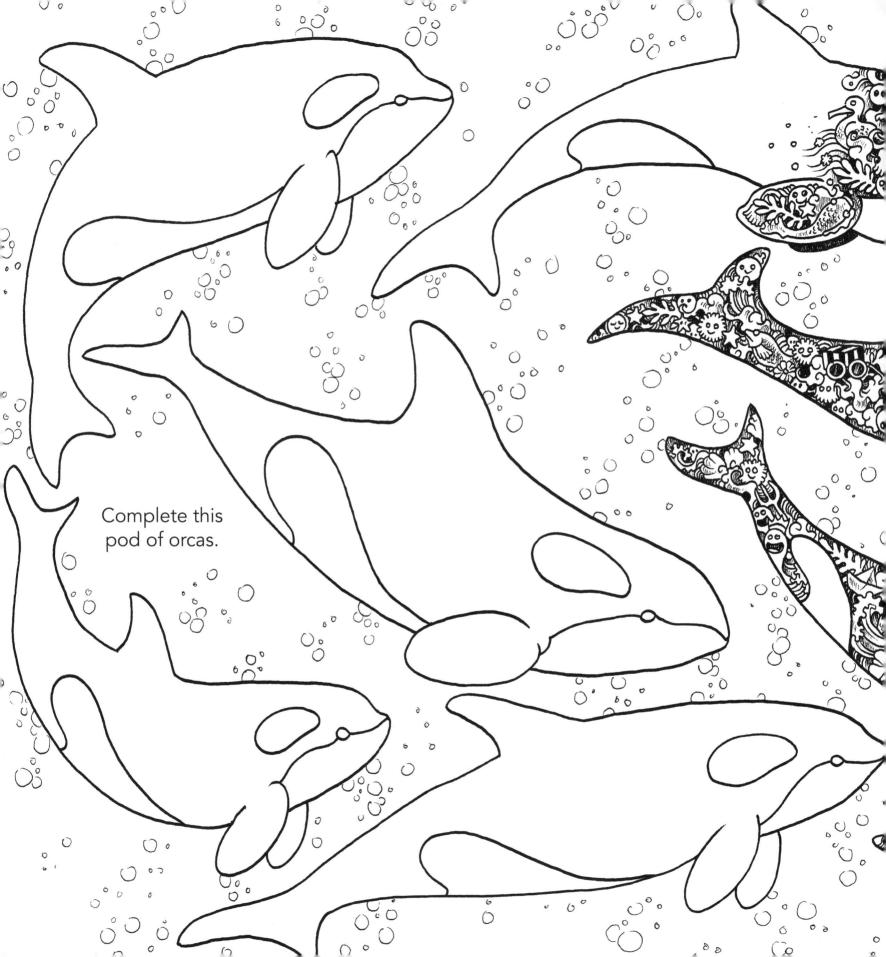

Complete this pod of orcas.

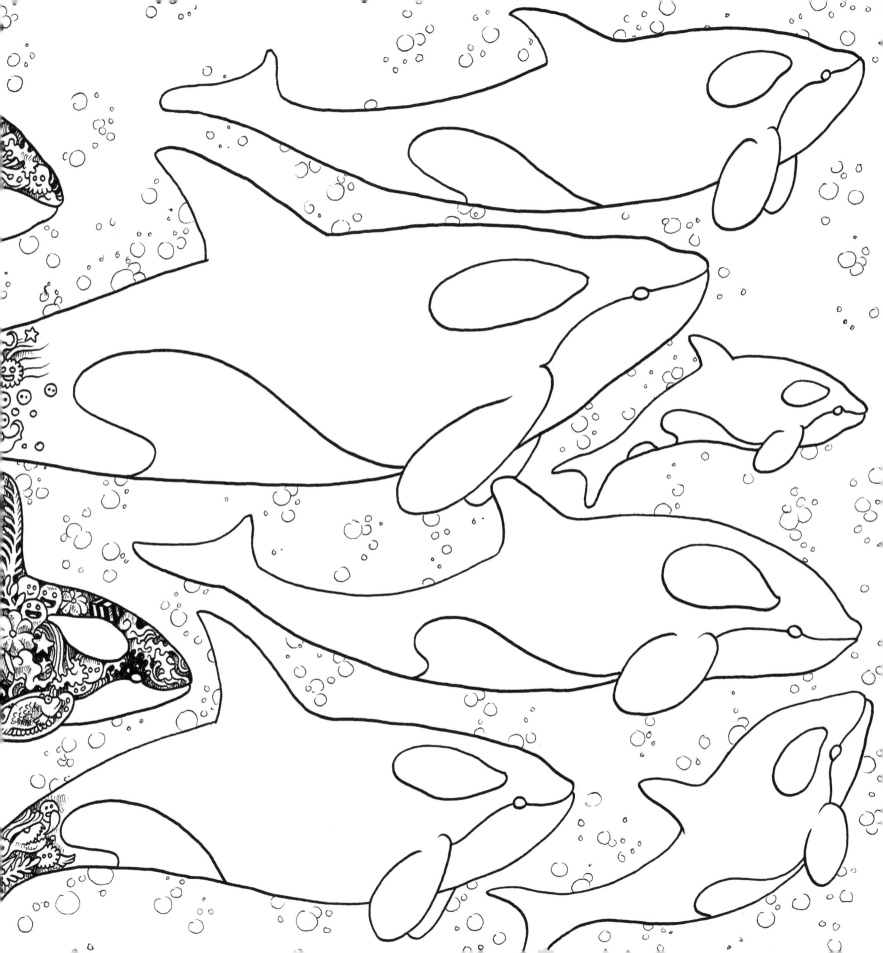

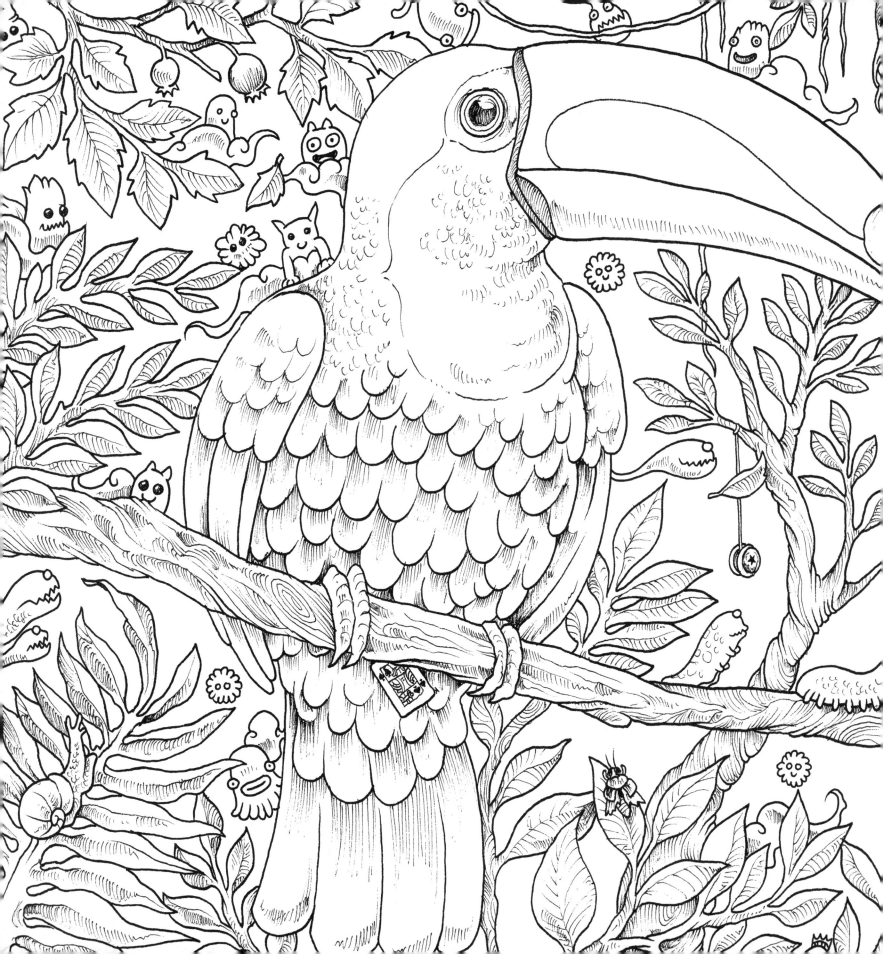

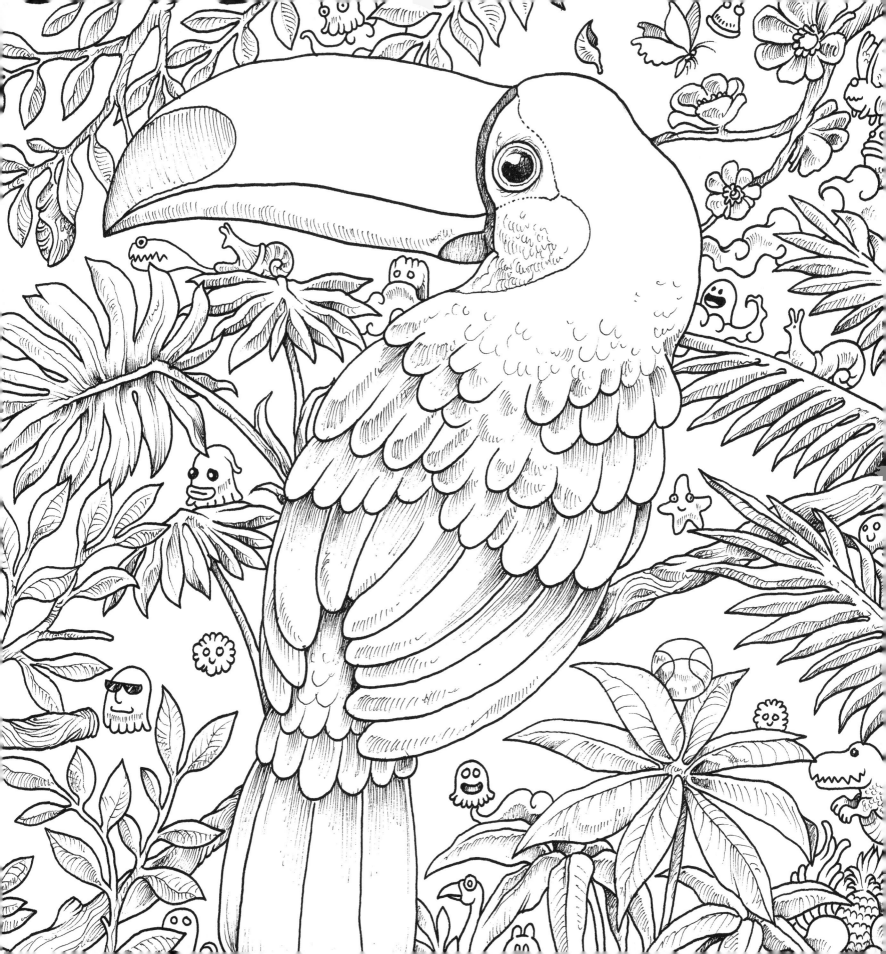

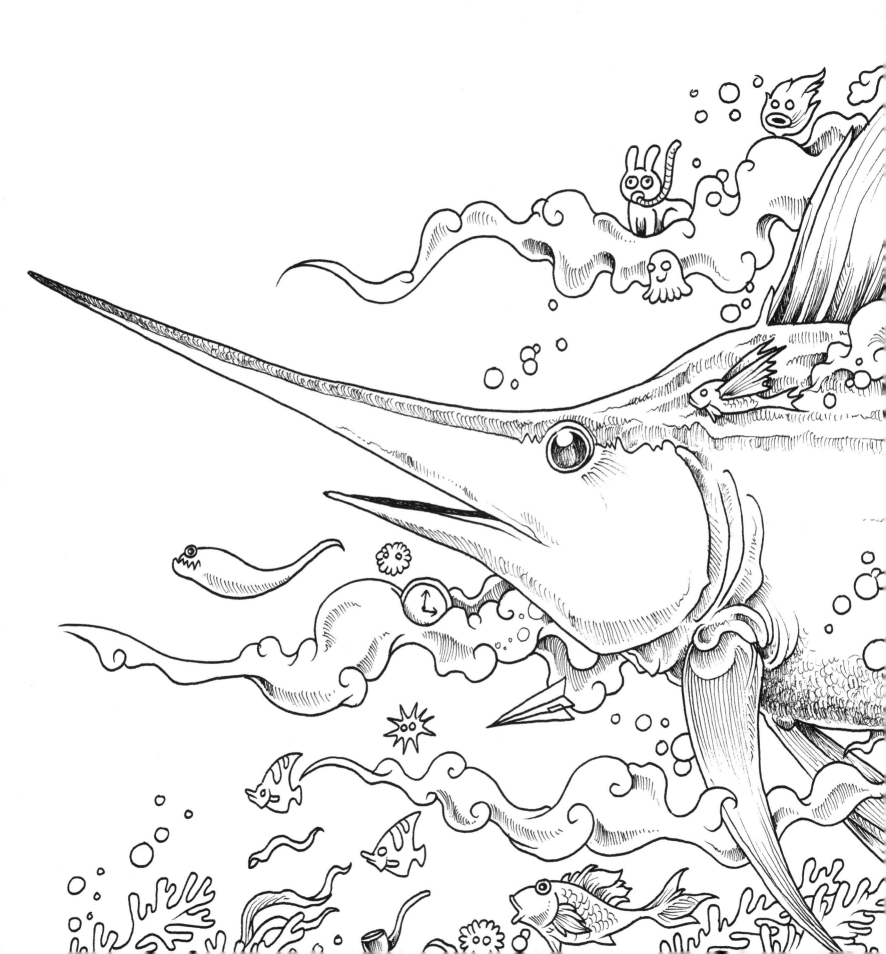

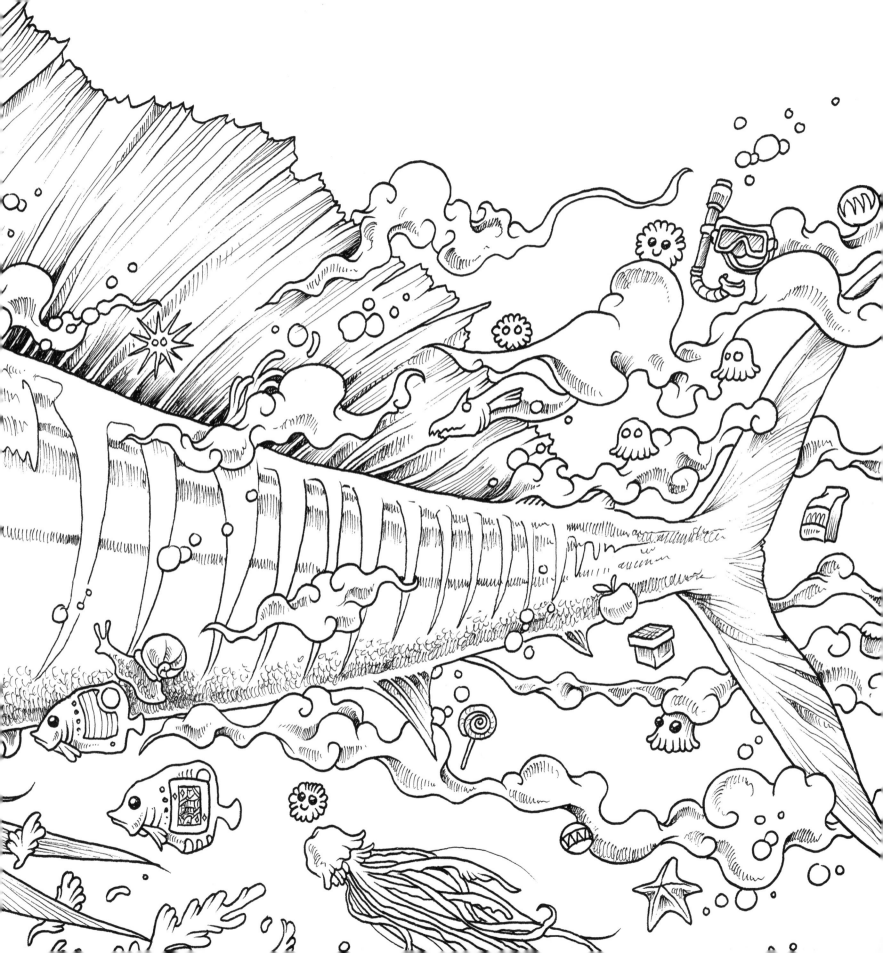

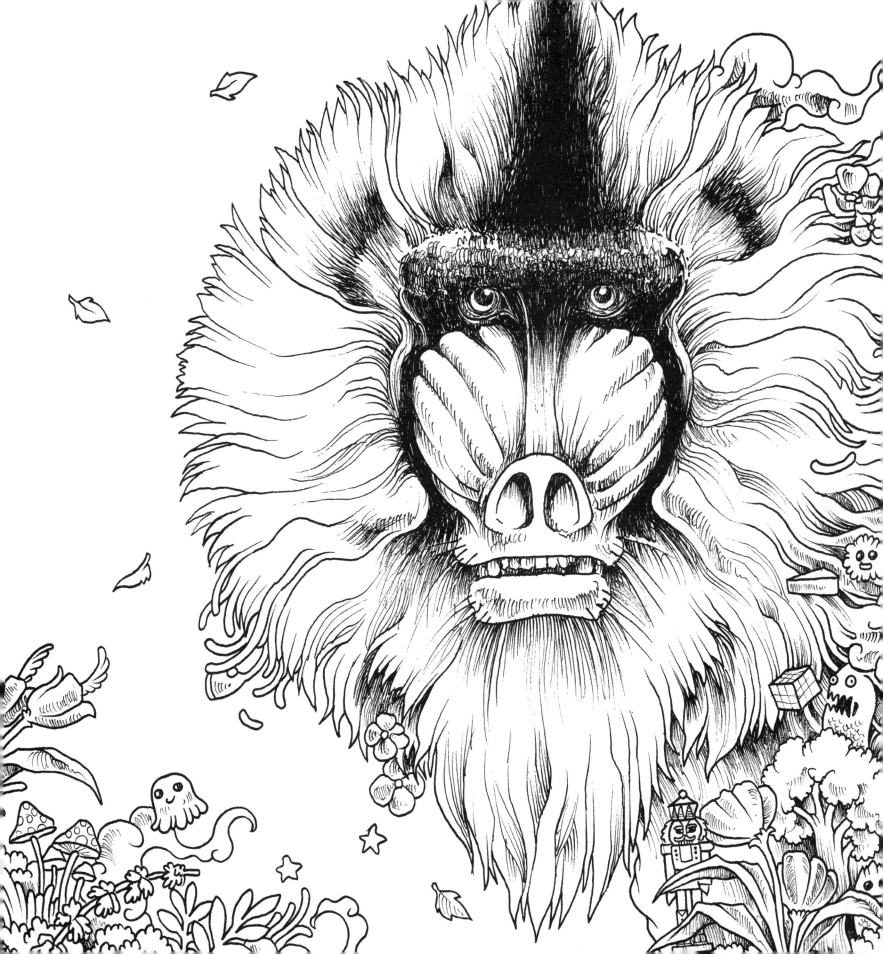

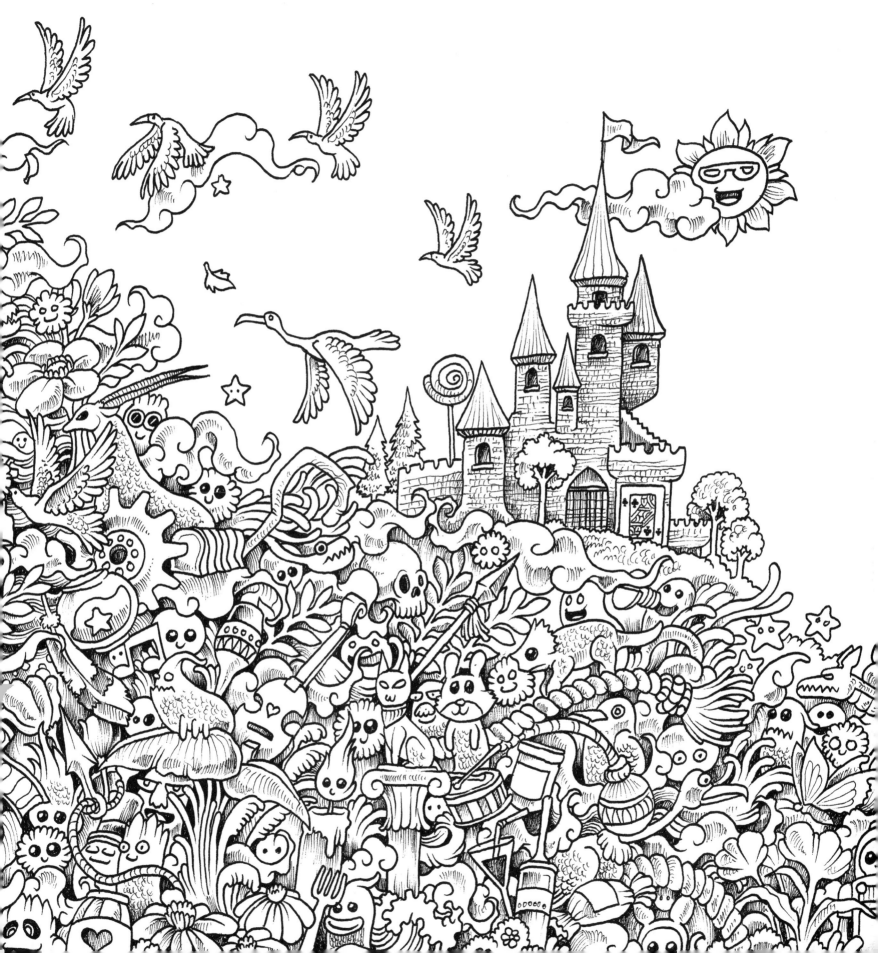

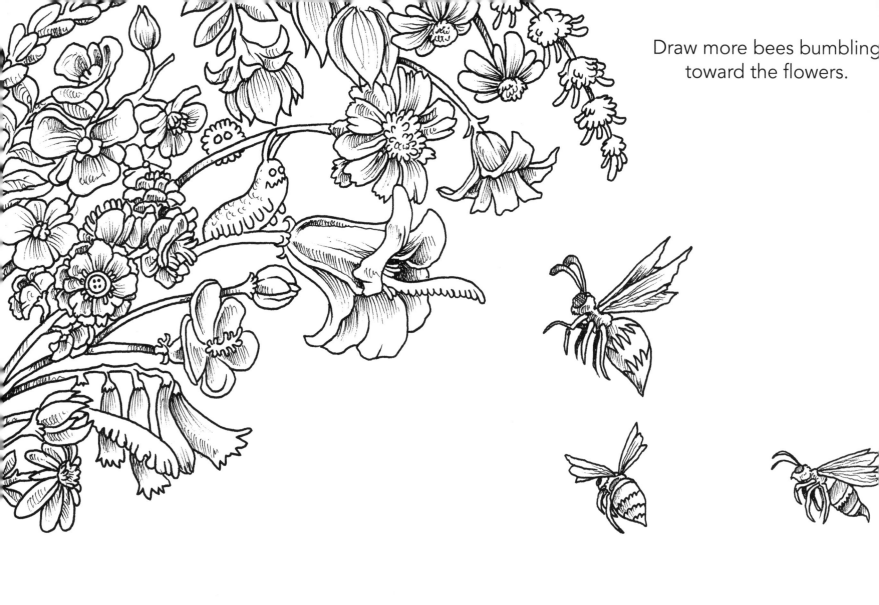

Draw more bees bumbling
toward the flowers.

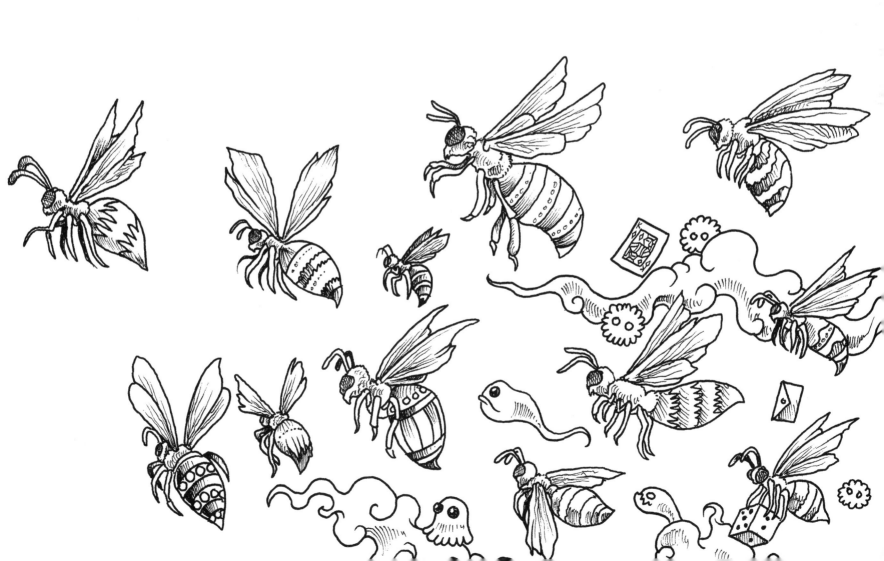

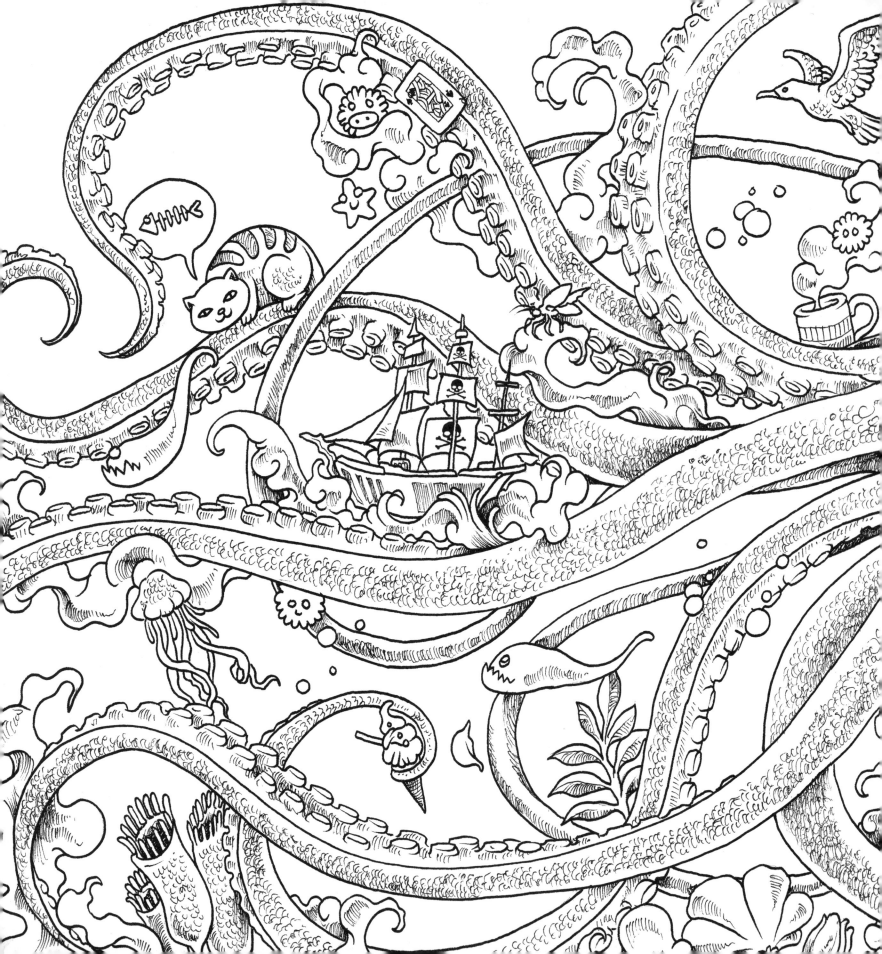

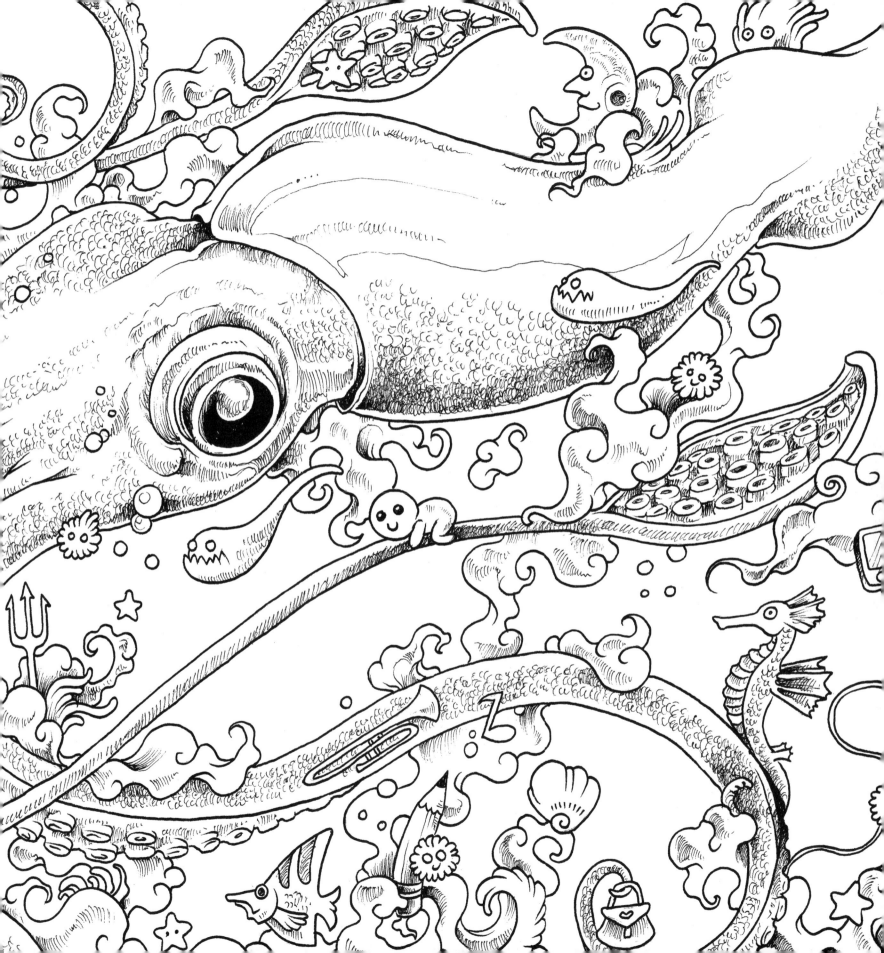

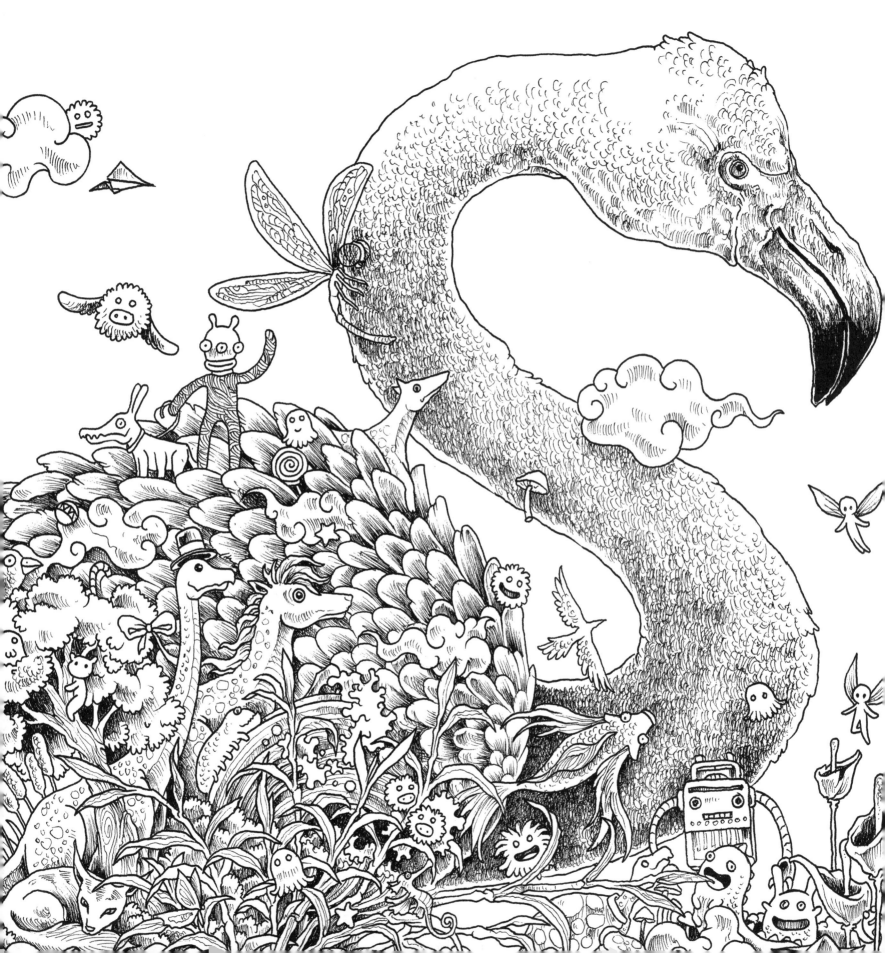

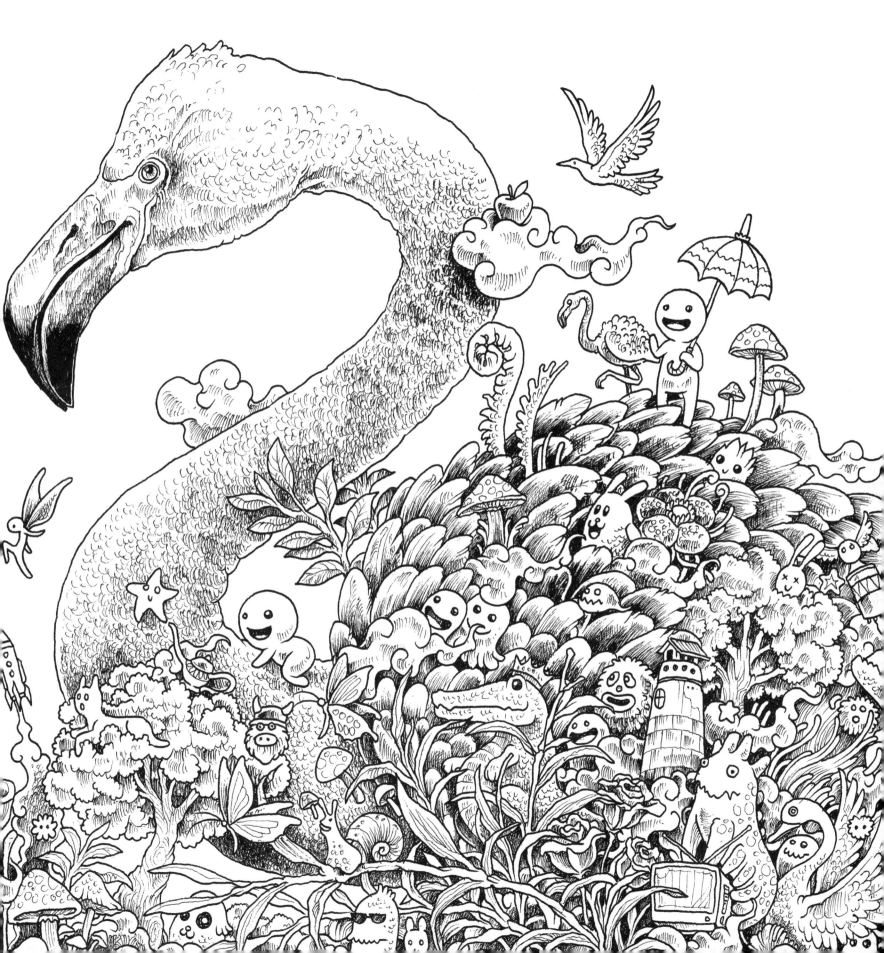

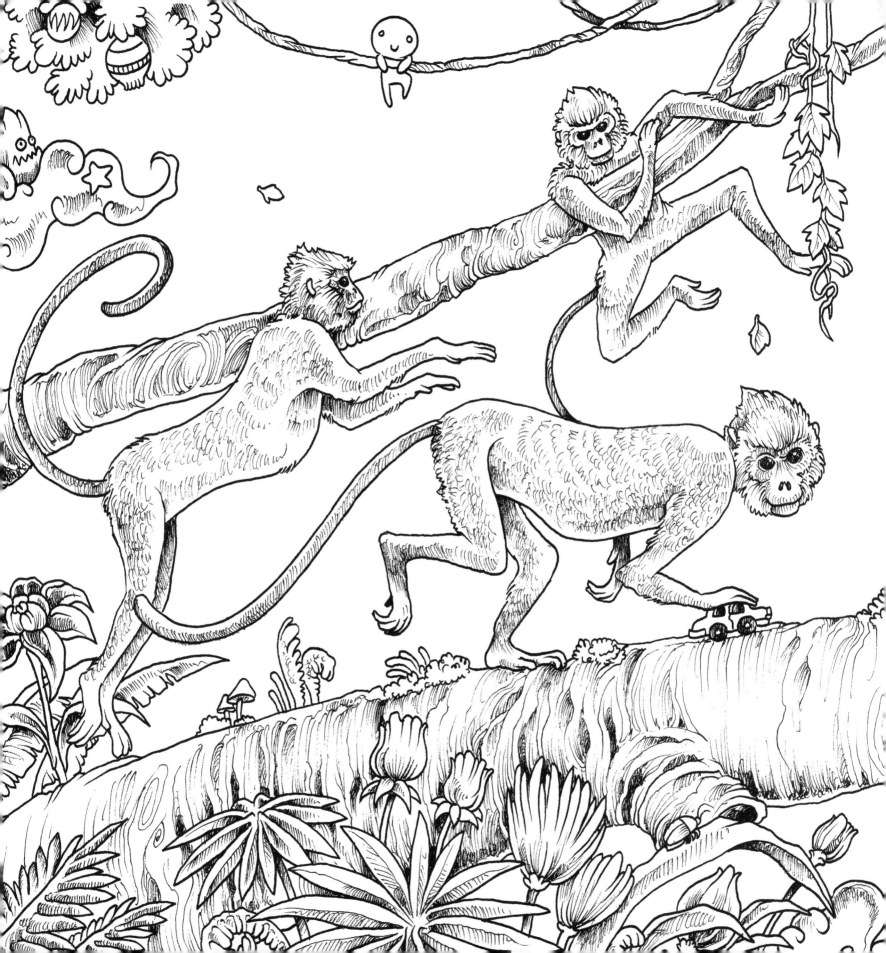

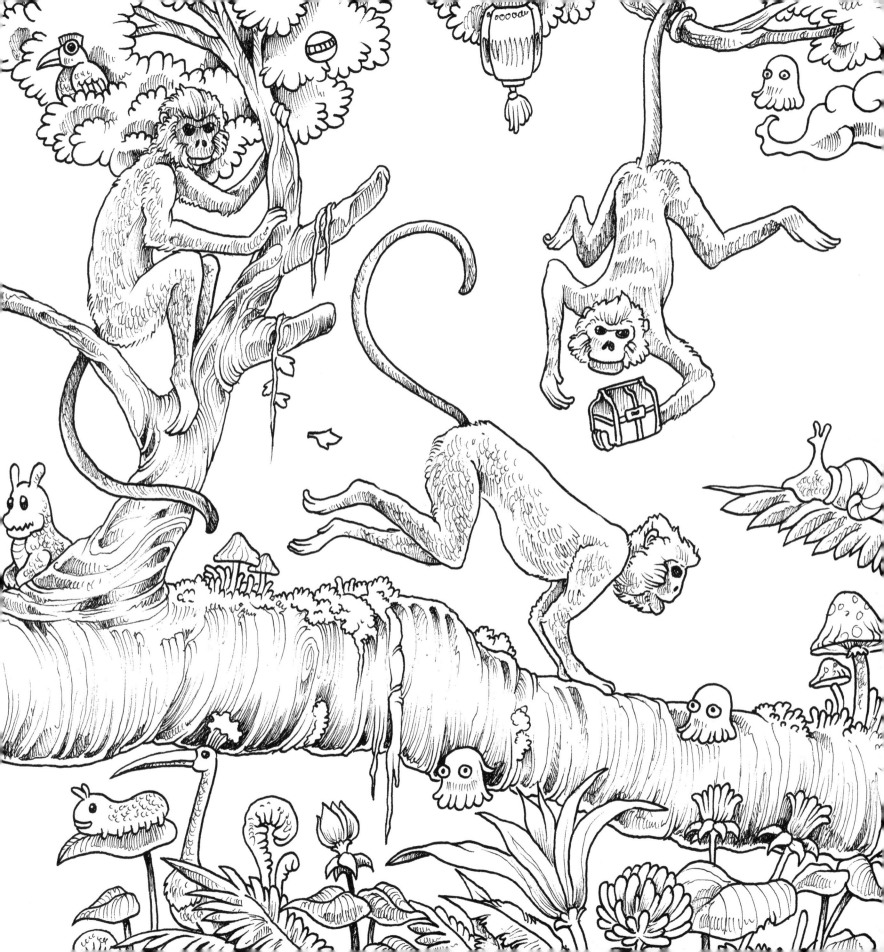

Can you find these items, artifacts, and creatures in the book?

When you have discovered them, color in the objects on the next few pages.

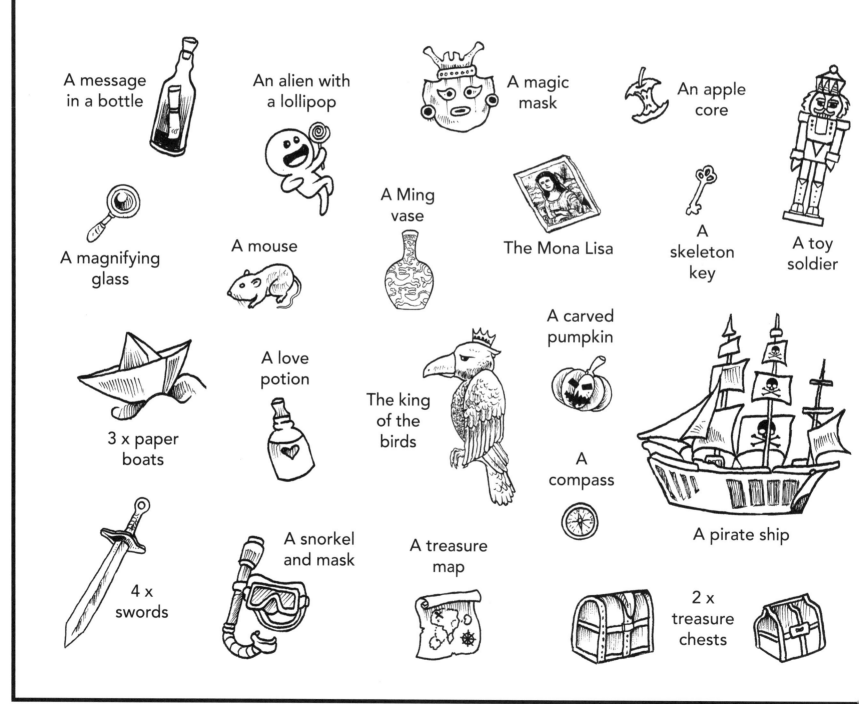

A message in a bottle

An alien with a lollipop

A magic mask

An apple core

A toy soldier

A magnifying glass

A mouse

A Ming vase

The Mona Lisa

A skeleton key

3 x paper boats

A love potion

The king of the birds

A carved pumpkin

A compass

A pirate ship

4 x swords

A snorkel and mask

A treasure map

2 x treasure chests

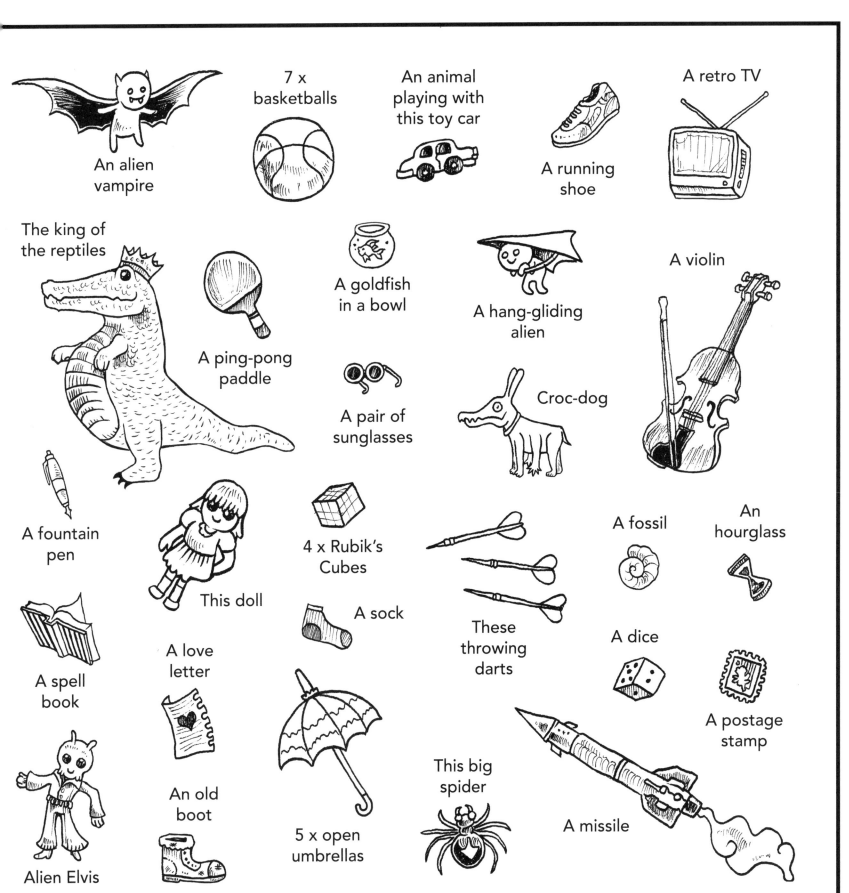

An alien vampire

7 x basketballs

An animal playing with this toy car

A running shoe

A retro TV

The king of the reptiles

A ping-pong paddle

A goldfish in a bowl

A hang-gliding alien

A violin

A pair of sunglasses

Croc-dog

A fountain pen

This doll

4 x Rubik's Cubes

A sock

These throwing darts

A fossil

An hourglass

A dice

A spell book

A love letter

A postage stamp

Alien Elvis

An old boot

5 x open umbrellas

This big spider

A missile

 2 x surfing aliens

A sparkly bracelet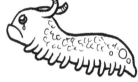

The king of the mammals

A scroll

A soccer ball

A scary doll

A watch on an animal's wrist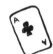

A drum with sticks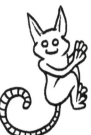

This grumpy caterpillar

This goblin

An alien witch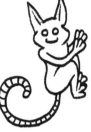

The Ace of Spades

The Ace of Clubs

The Ace of Hearts

The Ace of Diamonds

The King of Clubs

The King of Hearts

The King of Diamonds

The King of Spades

A yo-yo

A laptop

The Queen of Spades

The Queen of Hearts

The Queen of Diamonds

The Queen of Clubs

The Joker in the pack

A dinosaur egg

All the
Answers

The king of the birds

A surfing alien

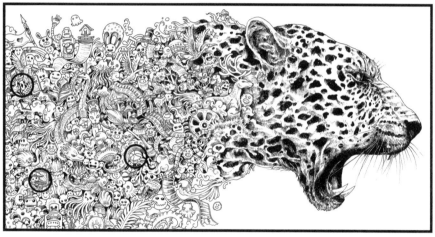

The Ace of Diamonds, a laptop, and a basketball

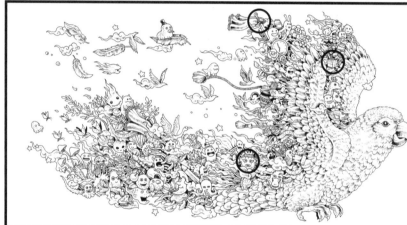

A magic mask, a Rubik's Cube, and a sword

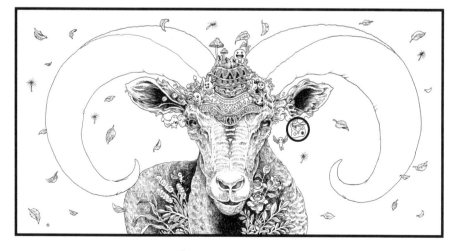

A treasure map

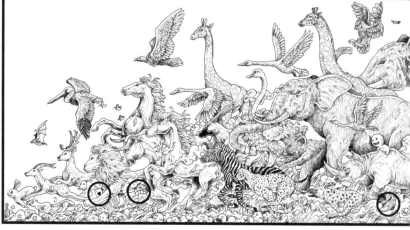

The Ace of Hearts, a running shoe, and a basketball

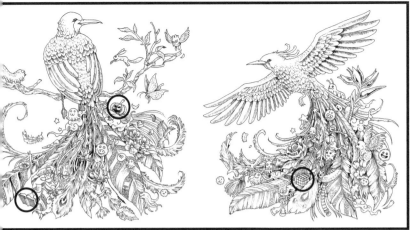

A carved pumpkin, a spell book, and a Rubik's Cube

Alien Elvis and a basketball

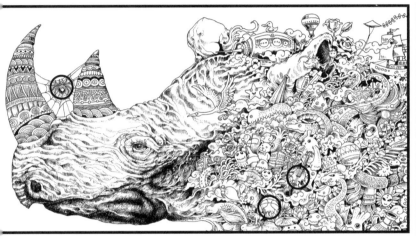

A big spider, a basketball, and a violin

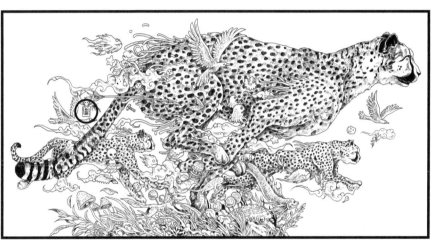

The Joker in the pack

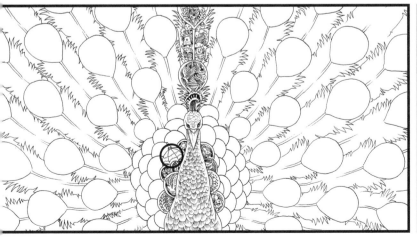

An open umbrella

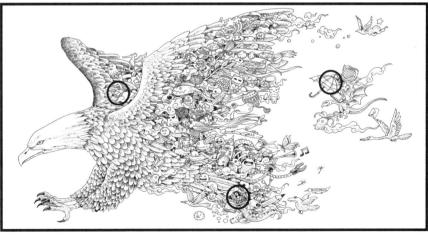

The Mona Lisa, an open umbrella, and a basketball

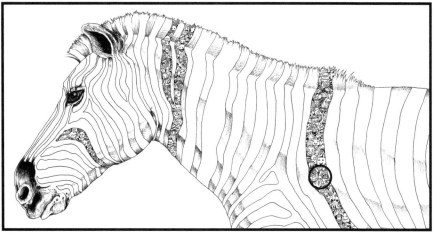

A fountain pen

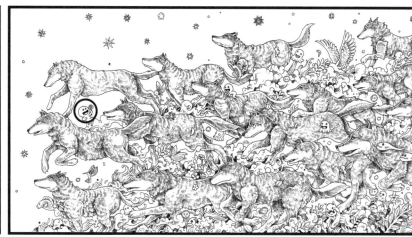

An alien with a lollipop

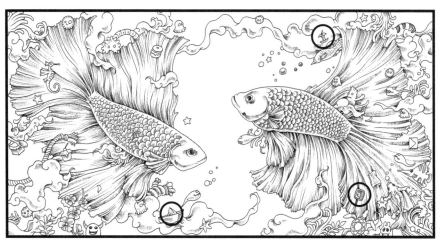

A postage stamp, a paper boat, and an apple core

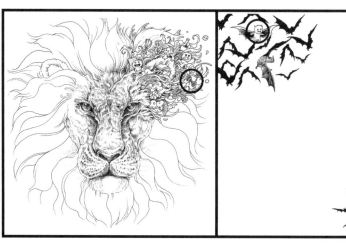

An hourglass and an alien vampire

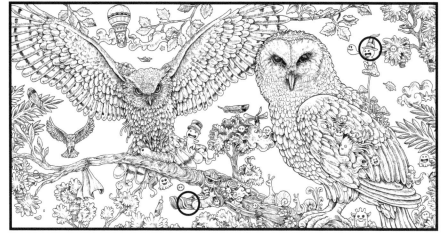

A Rubik's Cube and an alien witch

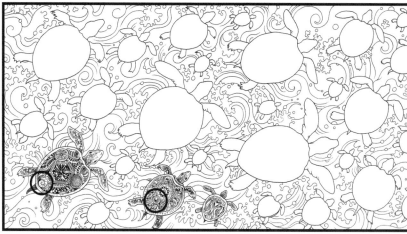

A fossil and a magnifying glass

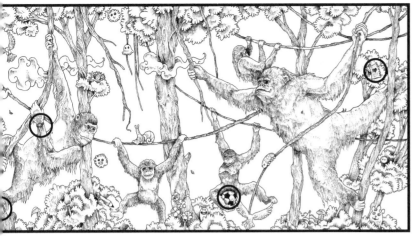

The Ace of Spades, a soccer ball, a love letter,
and a watch on an animal's wrist

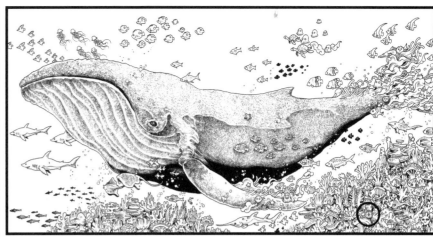

A compass

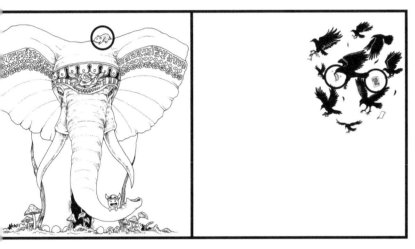

A mouse, the King of Clubs, and a sparkly bracelet

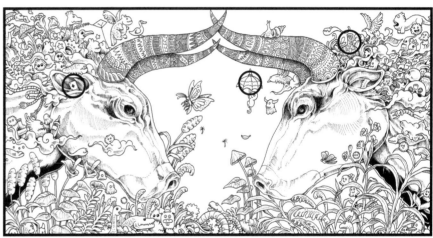

The Ace of Clubs, an open umbrella, and a Ming vase

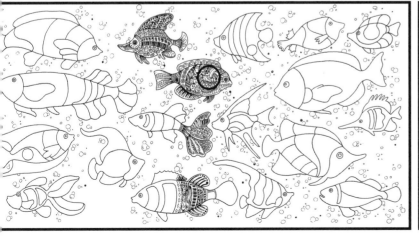

An old boot

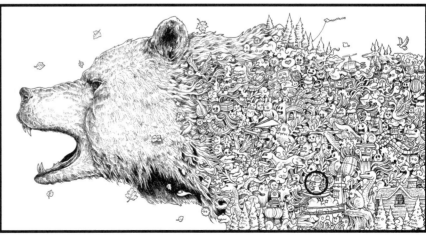

A surfing alien

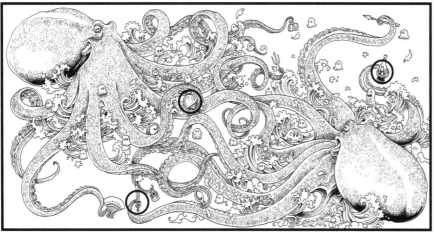

A ping-pong paddle, a sword, and a message in a bottle

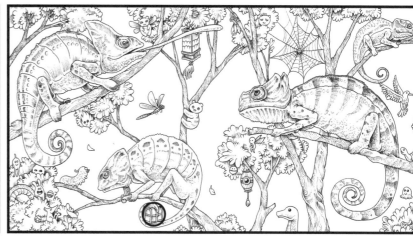

A treasure chest

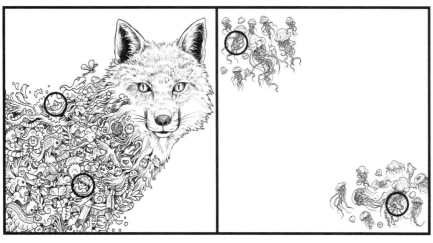

A doll, a paper boat, a sock, and a skeleton key

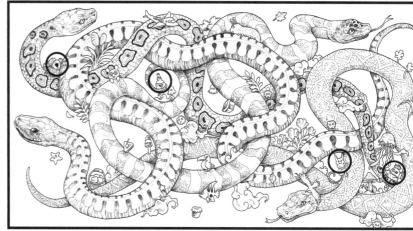

A dinosaur egg, a love potion,
a goblin, and a scary doll

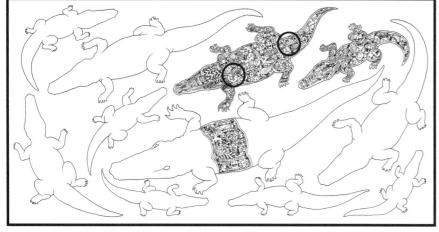

A goldfish in a bowl and a sword

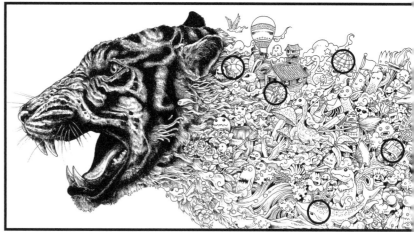

The king of the mammals, an open umbrella,
a scroll, a basketball, and a sword

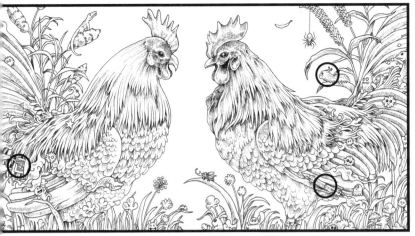

The King of Hearts, a grumpy
caterpillar, and a missile

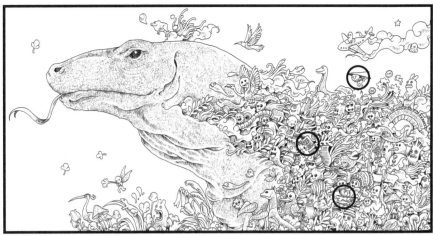

The Queen of Hearts, the throwing
darts, and a hang-gliding alien

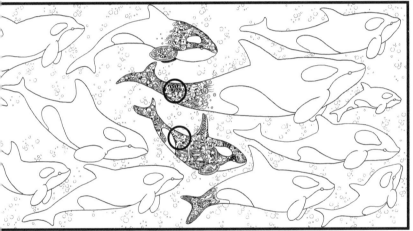

A paper boat and a pair of sunglasses

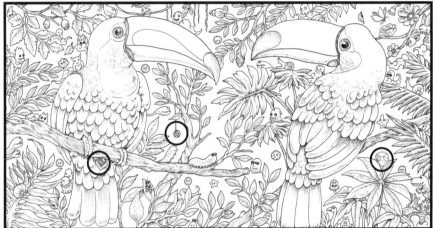

The King of Spades, a yo-yo, and a basketball

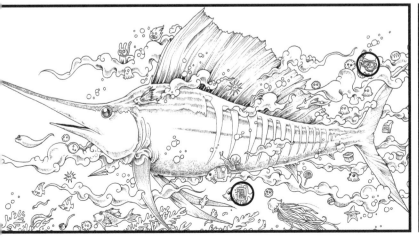

The Queen of Diamonds and a snorkel and mask

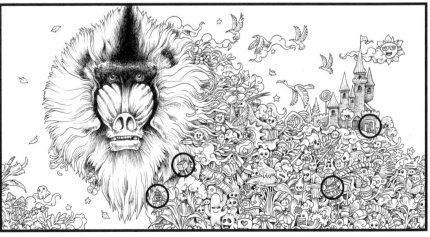

The Queen of Clubs, a Rubik's Cube,
a toy soldier, and a drum with sticks

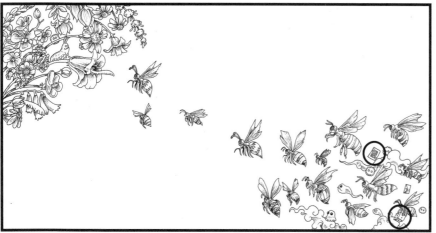

The King of Diamonds and a dice

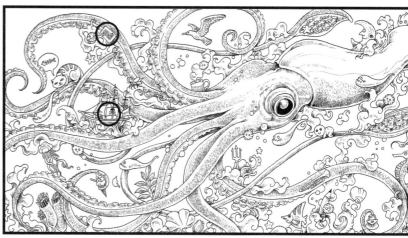

The Queen of Spades and a pirate ship

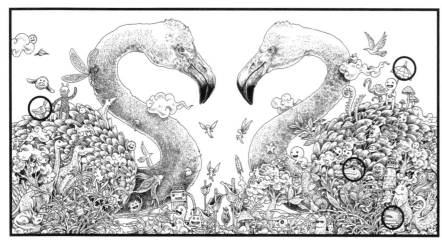

The king of the reptiles, Croc-dog,
a retro TV, and an open umbrella

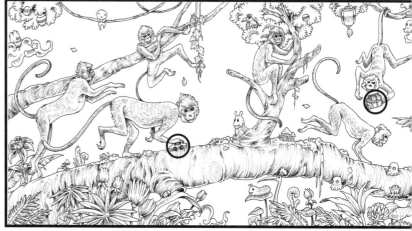

An animal playing with a toy car
and a treasure chest

The end

Share your creations:
#animorphia